THE
ANDEAN
HERITAGE

MASTERPIECES
OF PERUVIAN ART
FROM THE COLLECTIONS
OF THE PEABODY MUSEUM

GARTH BAWDEN

GEOFFREY W. CONRAD

PEABODY MUSEUM PRESS
CAMBRIDGE, MASSACHUSETTS • 1982

DISTRIBUTED BY HARVARD UNIVERSITY PRESS

The Andean Heritage is an exhibition of the pre-Columbian Peruvian artifacts from the collections of the Peabody Museum of Archaeology and Ethnology, Harvard University.

Photographs by Hillel Burger

Contents

Foreword

A new exhibition at the Peabody Museum is a very special event. During the past several decades the museum has had very few exhibitions on the scale of "The Andean Heritage: Masterpieces of Peruvian Art from the Collections of the Peabody Museum." Moreover, this is the first exhibition in more than three decades to feature the Peruvian collections, and it is the second in a series of highlight exhibitions from the Peabody's collections that are planned for our new rotating gallery funded by the National Endowment for the Arts. An understanding of why the Peabody does not participate more often in large-scale exhibition programs involves an understanding of the nature of the museum itself. The Peabody is principally a research and teaching institution. Exhibitions today are inordinately expensive to install, and the limited resources of the museum must necessarily be expended on research programs that extend around the world. Thus, it is exciting when the museum is fortunate enough to be awarded funds from federal and state agencies, in this case the National Endowment for the Arts and the Massachusetts Council on the Arts and Humanities. The "Andean Heritage" will clearly demonstrate the museum's commitment to public exposure of its fine collections whenever possible.

Students of human history generally agree that the stage of development termed "civilization," with its cities and great art styles, always followed the creation of effective food production. Only then were large numbers of people freed from the arduous subsistence tasks that dominated the activities of less evolved societies. From these groups emerged the specialists whose functions characterize urban civilization — bureaucrats, priests, soldiers, and craftsmen. Artisans, often working for the emergent states, produced the accomplished art styles that were among the hallmarks of early civilization and that in their surviving manifestations rank high among the treasures of human cultural heritage as a whole.

Emergent civilization with its wide range of material attributes is well known in the Old World, where the brilliant examples of Egypt, China, and Mesopotamia have long defined the term. However, the universality of this aspect of human achievement is less well recognized. In the New World, civilization appeared in two areas: Mesoamerica and the Central Andes of South America — essentially present-day Peru. Although the early American civilizations differed greatly in detail from their Old World counterparts, their intellectual achievements, organizational skills, and material accomplishments were no less fine. Great cities, the centers of political states ruled by divine kings, were the settings for brilliant expressions of human aesthetic creativity. The Peruvian

center of New World civilization, with its almost 5,000-year-long evolution from small villages to the vast Inca Empire, should be seen not only as a distinctly New World cultural manifestation but also as an example of a wider aspect of human experience, whose implications are universal both in territorial extent and historical depth.

"The Andean Heritage" exhibits a small portion of our Peruvian collections. It is our hope that through the artifacts displayed the visitor will be brought to a deeper appreciation of the extraordinary richness of one of the most creative of New World civilizations. The exhibition is greatly enhanced by the publication of this catalogue, which is far more than a pictorial record of the items on exhibit. The work provides the visitor with an essay on Peruvian culture history, an interpretation of this civilization's aesthetic accomplishments, and a descriptive section detailing the major Peruvian art styles. The reading of this work will encourage an appreciation of the objects exhibited within an anthropological context of Peruvian civilization.

This exhibition is the result of the collaboration of numerous people. Among the many individuals who made it possible, I would particularly like to thank the curator and principal catalogue author, Dr. Garth Bawden, his coauthor, Dr. Geoffrey Conrad, the exhibition designer, Mr. Addis Osborne, the photographer, Mr. Hillel Burger, the editors of this catalogue, Ms. Lorna Condon and Ms. Donna Dickerson, staff artist, Ms. Whitney Powell, and the conservators, Ms. Linda Merk and Mr. Stephen Mellor. I would also like to thank the National Endowment for the Arts, the Massachusetts Council on the Arts and Humanities, and the Peabody Museum Association, whose contribution of funds made the exhibition and its catalogue possible.

C.C. Lamberg-Karlovsky
Director

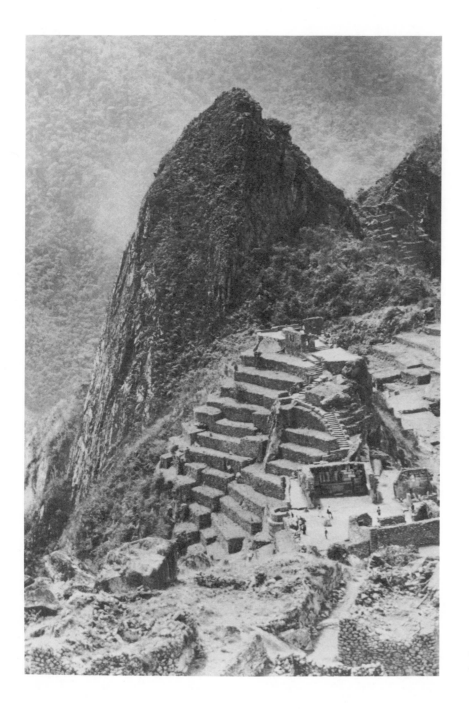

The Inca settlement of Machu Picchu, upper Urubamba River.

Introduction

The Peruvian archaeological collections of the Peabody Museum rank among the finest in the world. Because of their great size, rich variety, and quality of preservation, these collections are unmatched outside of Peru. Thousands of fine ceramics, textiles, and items of precious metal are supplemented by smaller collections of wood, shell, stone, and bone to form an excellent representative sample of the cultural heritage and artistic expression of pre-Columbian civilization of Peru. A relatively small quantity of this material has been selected for the exhibit "The Andean Heritage: Masterpieces of Peruvian Art from the Collections of the Peabody Museum."

The label "masterpiece" as applied to art infers achievement of the highest aesthetic level and technical skill, and thus should not be used lightly. We believe that no one who views this exhibit will either disagree with the propriety of using this label to describe the displayed works or will doubt the artistic brilliance of their creators. "The Andean Heritage" will fully illustrate all aspects of Peruvian artistic expression and demonstrate their great significance toward understanding the wider vistas of the society in which they played an important role.

The story of the Peabody Museum's involvement in Peruvian cultural studies spans virtually the entire history of the institution. Founded in 1866 by George Peabody, the museum was without its own building until 1877. However, during this first decade the process of accumulating material holdings for study and display was initiated. Some of the principal acquisitions, comprising a broad variety of archaeological items, came from Peru. Most of these items came from extensive pre-Columbian cemeteries scattered along the Peruvian coastal desert, where extreme aridity results in excellent preservation of all types of material. Paramount among these early acquisitions were those donated by one of the strongest supporters of the early Peabody Museum and long-time director of the neighboring Museum of Comparative Zoology, the great natural historian Louis Agassiz, and following his death in 1874, those donated by his son Alexander. A notable segment of the Agassiz material was obtained during the famous scientific expedition to Central and South America undertaken in 1871 in the vessel *Hassler*. The *Hassler* expedition provided the Peabody Museum with the first articles in both its textile collection, which now ranks among the finest in the world, and its splendid ceramic holdings.

These early acquisitions characterized a period of initial growth which lasted from the foundation of the museum into the 1880s. It was during this time that the early museum directors Jeffries Wyman and Frederic Ward Putnam, reflecting

upon the state of anthropological enquiry in the late nineteenth century, endeavored to accumulate large comparative collections of archaeological, skeletal, and ethnological material from throughout the world with special emphasis on the New World. These collections were to form the basis for research on the nature of human cultural and physical development, especially in the Americas, and for understanding similarities and differences between such development in the Old and New Worlds. Within the framework of this intellectual approach, the bulk of the Peruvian archaeological collections was brought together. During this period, the Agassiz gifts were complemented by many others: notably the large Blake collection, which was transferred from Harvard Medical School's Warren Anatomical Museum in 1877; the Bucklin collection, mostly of ceramics, in 1879; and Dr. W. Sturgis Bigelow's fine textile collection in 1880.

Until 1877 when the first section of the present building was constructed, the Peabody Museum was unable to exhibit much of its expanding holdings. However, following the erection of the museum, one of the most important of the new galleries was devoted to the extensive South American material. The South American Room on the third floor was completed in 1880. This gallery utilized display methods far different from those of the present exhibit. As can be seen in the photograph of this gallery on page 3, little effort was devoted to arranging the items in a visually stimulating or interpretive display. Instead, objects were crammed together on shelves by shape and area of origin. Consequently, there was little opportunity for the uninformed viewer to gain information regarding the functions, chronological development, or wider cultural contexts of the objects in Peruvian civilization.

These early exhibits, although important in exposing previously little-known aspects of pre-Hispanic Peruvian culture to the general public, were oriented toward the scholarly observer, thus obviating the necessity for visually pleasing and explanatory displays. Indeed, through the first half of the twentieth century the collections, representing as they do significant aspects of material culture, were directly used as teaching vehicles by Harvard's Department of Anthropology, which evolved from the Peabody Museum in the 1890s. Concurrently, with the major comparative collections in hand, large-scale acquisition decreased, although throughout the museum's subsequent existence there has been intermittent addition of Peruvian items.

The only exception to this trend occurred in the late 1930s, when the museum, barred from the Old World because of imminent war, mounted a broad anthropological program in the Andes. This program, encompassing ethnography, archaeology, physical anthropology, and ethnohistory, continued until the mid-1940s and resulted in the largest influx of Peruvian material into the Peabody Museum in the twentieth century. The paramount acquisition of this period was

The South American Room at the Peabody Museum, about 1890.

the splendid collection of archaeological materials accumulated by Samuel K. Lothrop, then Curator of Andean Archaeology. The most important portion of this collection consisted of textiles, among them some of the finest specimens extant outside of Peru. These textiles are represented in the present exhibit. Subsequent to the 1940s, only a small quantity of Peruvian material has reached the Peabody, although the Museum's involvement in Andean research has been maintained. Moreover, the permanent Peruvian exhibit was dismantled in the late 1950s, its gallery being utilized for other purposes, so that for the last thirty years little of the extensive Peruvian holdings has been available for public viewing. Thus, the time is opportune for an exhibit of this material, especially so in view of a recently completed major conservation program devoted to preserving and organizing the textile collection and making it secure for public display.

The present exhibit, in a new and modern setting, reflects more than a century of the Peabody Museum's heritage of research and education relating to Peruvian pre-Columbian culture. The relatively few items on display are merely a representative sample of the finest objects from these multifaceted collections, selected not only to illustrate the exquisite quality of Peruvian artistic expression but to best explain the broader cultural systems of which they were integral components.

4

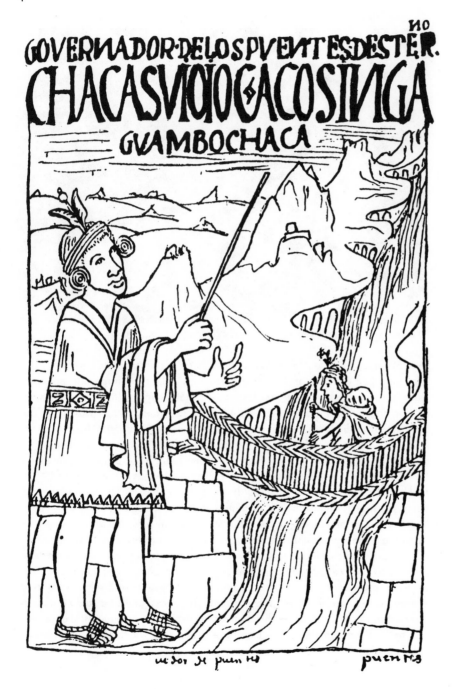

GOVERNADOR·DELOSPVENTESDESTER.no
CHACASVIOIOCACOSIVIGA
GVAMBOCHACA

uidor H puente puen te g

Guaman Poma's depiction of the complex and highly organized Inca road system in the Andes.

Peoples and Cultures

Who were the inhabitants of ancient Peru? Most people automatically think of the Incas. This is correct in one sense. When Spanish conquistadors entered Peru in 1532, all of the regions covered by this exhibit, plus huge areas to the north and south, lay inside the borders of the Inca Empire. From the southern frontier of modern Colombia to central Chile, the Inca realm was more than 4,300 kilometers (2,600 miles) long. Within this vast territory, at least six million people, and perhaps as many as thirty million, obeyed the commands of Inca officials, paid taxes to Inca rulers, served in Inca armies, worshipped Inca gods, and spoke Quechua, the Inca language, for administrative purposes. Small wonder, then, that when we consider ancient Peru, most of us think first and foremost of the Incas.

Yet, if we think only of the Incas, we mislead ourselves. For one thing, beneath its veneer of unity the Inca Empire was a land of incredible diversity. All of its inhabitants were American Indians, but they were divided into a bewildering array of tribes and ethnic groups. We do not know the exact number of peoples involved, but in Inca times the area covered by this exhibit alone contained nearly 100 administrative provinces, each the homeland of one or more ethnic groups. Despite their overarching political power, the Incas themselves — the "Incas by blood" — were only one small group among the many native peoples of Peru at the time of the Spanish conquest.

Tribal differences were matters of great importance to the Inca rulers and their subjects. Ethnic identities were maintained not just through the force of tradition, but by imperial laws concerning costume, residence, tax obligations, and so on. As a result, the early Spanish colonists of Peru were able to distinguish among the various groups they met and to describe them in greater or lesser detail. Colonial Spanish accounts make it possible for us to recognize the different peoples of late prehistoric Peru when we encounter them archaeologically. So, for example, when we speak of Lupaqa ceramics, we mean distinctive styles of pottery made by the Lupaqa, members of a tribal kingdom who occupied part of the western Titicaca Basin and who were conquered by the Incas between approximately A.D. 1450 and 1460. Likewise, when we identify other artifacts as Chanca, Huanca, Chincha, and so forth, we are attributing them to specific ethnic groups that were eventually incorporated into the Inca Empire.

Still, in realizing that the Inca realm was a mosaic of tribes, we have only begun to appreciate the enormous diversity of Peru's native cultures. The Inca Empire lasted only a century (ca. A.D. 1438–1532), and most of its historically documented ethnic groups do not appear in the archaeological record until about

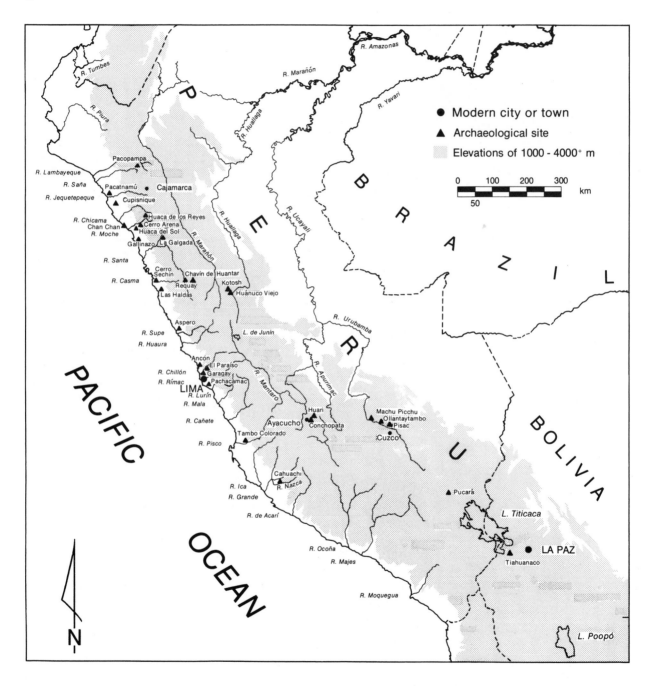

R. Tumbes

R. Piura

R. Marañón

R. Amazonas

R. Yavari

P

E

R

U

B

R

A

Z

I

L

BOLIVIA

● Modern city or town

▲ Archaeological site

Elevations of 1000 - 4000⁺ m

0 100 200 300
50 km

R. Lambayeque

R. Saña

R. Jequetepeque

R. Chicama

R. Moche

R. Santa

R. Casma

R. Supe

R. Huaura

R. Chillón

R. Rímac

R. Lurín

R. Mala

R. Cañete

R. Pisco

R. Ica

R. Grande

R. de Acarí

R. Ocoña

R. Majes

R. Moquegua

R. Huallaga

R. Ucayali

R. Marañón

R. Huallaga

R. Urubamba

R. Apurímac

R. Mantaro

Pacopampa

Pacatnamú

Cajamarca

Cupisnique

Huaca de los Reyes

Cerro Arena

Chan Chan

Huaca del Sol

Gallinazo

La Galgada

Cerro Sechin

Chavín de Huantar

Requay

Kotosh

Las Haldas

Huánuco Viejo

Aspero

L. de Junín

Ancón

El Paraíso

Garagay

LIMA

Pachacamac

Huari

Ayacucho

Conchopata

Tambo Colorado

Machu Picchu

Ollantaytambo

Pisac

Cuzco

Cahuachi

R. Nazca

Pucará

L. Titicaca

LA PAZ

Tiahuanaco

L. Poopó

PACIFIC

OCEAN

N

A.D. 1200. Beneath them lies their ancestry — at least 11,000 years of human habitation in Peru — and a tradition of civilized life more than 4,500 years long.

The ancient Peruvians never developed writing, and we have no eyewitness accounts of their lengthy heritage. Instead, we must rely upon the data of archaeology. Hence, for most of Peruvian prehistory we do not speak in terms of "tribes," "peoples," or "ethnic groups." Instead, we discuss "archaeological cultures" — cultural entities defined by unique styles of artifacts with limited distributions in space and time. We assume that an archaeological culture consists of materials made by a group of people who saw themselves as distinct from everybody else. Even though experience generally upholds this assumption, there are enough counterexamples to prevent us from speaking with complete confidence.

The cultures named in this exhibit dating prior to A.D. 1000 are archaeological cultures. What exactly do the Moche or Tiahuanaco cultures represent? Such questions are often highly controversial. We can offer carefully considered opinions but not definitive answers. Thus, this account, in common with all descriptions of Peruvian prehistory, must remain speculative in its detail although accurate in its general interpretations.

Ancient Peru.

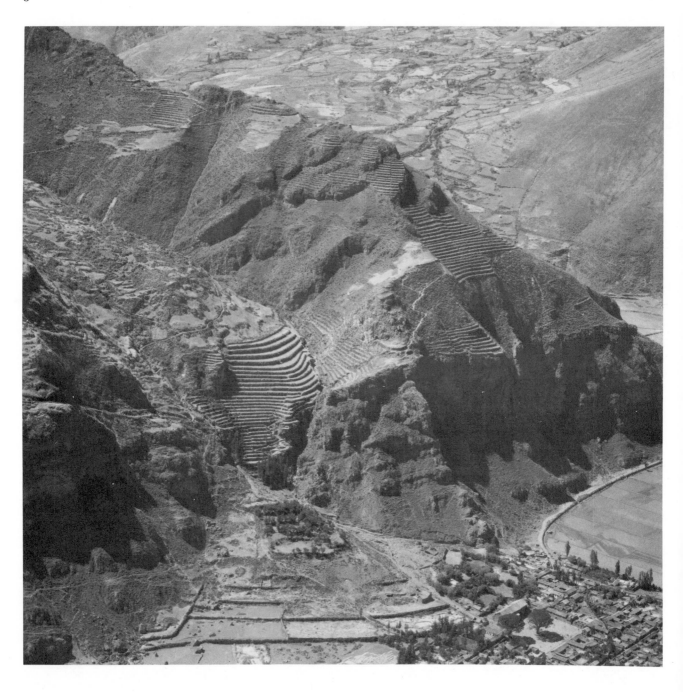

Land and Peoples

The Geographical Setting

It is impossible to comprehend the course of Peruvian cultural development without an awareness of its physical setting. The Andean natural environment, one of the most dramatic and diverse in the world, not only played a vital role in molding the general economic and political history of the region but also directly influenced the form of specific cultural components such as art.

The area within which pre-Columbian Peruvian civilization emerged and flourished as an indigenous phenomenon closely approximates the modern country of Peru, excluding most of the jungle region in the east and with a southward extension to the Titicaca Basin. This huge region is one of vividly contrasting bands of natural environment extending from the littoral eastward across a narrow coastal desert to the high Andes and the equatorial jungles beyond. Because of the importance of these various habitats in shaping Peruvian civilization in its numerous regional expressions, we shall briefly describe them in turn, each with its distinct set of implications for human cultural development.

The Peruvian Maritime Environment

The Pacific Ocean, as it washes the coast of Peru, creates a complex natural environment, one of whose characteristics is the generation of a constantly renewed marine food supply. The source of this abundance is the Peruvian Coastal Current, usually called the Humboldt Current after the great nineteenth-century German natural historian and explorer of South America, Alexander von Humboldt. The Humboldt Current sweeps northward along the western coast of the South American continent before veering to the west off northern Peru. This current is merely the easternmost component of the great counterclockwise superficial circulation pattern of the South Pacific Ocean; however, its location along the Peruvian coast above cold upwelling water from the deep offshore ocean trough gives it a character that vitally affects the nature of human occupation in the coastal region. The naturally warm tropical surface flow is constantly being replaced in the Humboldt Current by cold, deep ocean water, which brings with it rich nutrient salts, the basic food source for minute sea vegetation which in turn forms the first link in an elaborate food chain which rises through microscopic marine herbivores, small fish and crustaceans, sea mammals and fowl, and ultimately man. The abundance of this marine food production is illustrated by the fact that modern Peru ranks high among the world's leading commercial fishing

Inca agricultural terraces, central Andes near Pisac.

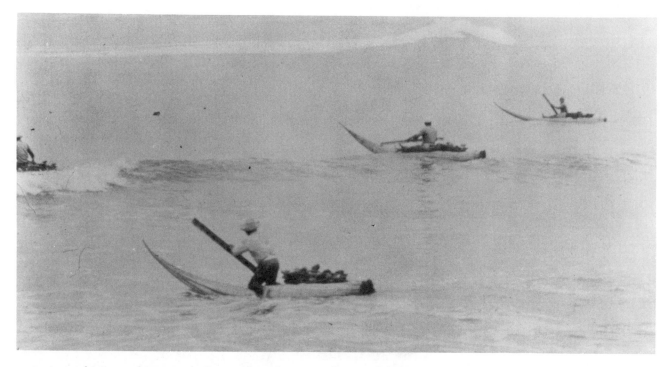

countries; and prior to the recent decline resulting from a combination of adverse climatic conditions and overfishing, Peru led the world in anchovy production. It is this potential for constant natural food generation and replenishment that allowed the creation along the Peruvian coast of one of the earliest expressions of pre-Columbian civilization in the New World.

Modern Peruvian fishermen using traditional reed rafts (see p. 65), Huanchaco.

The way of life that emerged along the Peruvian coast and that, with modifications, still persists is one primarily based on inshore fishing combined with plant gathering and animal hunting along the littoral. The fish and sea mammal harvests of the ocean were supplemented by the collection of crustaceans, mollusks, and edible vegetation and by hunting of small coastal land mammals, deer, and sea fowl to provide the subsistence base for an elaborately organized society. The sheer abundance of this food supply permitted the growth from small scattered villages to large complex communities soon after 3000 B.C. These communities constituted the antecedents of coastal Peruvian civilization.

The early maritime developments that we have just documented also incorporated many of the elements that were later to characterize Andean civilization in general. On the technological level, the invention of reed boats to fish the Humboldt Current presaged a custom that persists thousands of years later. Large-scale architecture in the form of elaborate mud-brick pyramids with

attached terraces and multiroomed enclosures, an ever-present component of all later stages of ancient Peruvian settlement, made its first appearance along the coast in the early maritime sites, accompanied by large domestic residential areas. Moreover, the Peruvian textile tradition emerged at this time with its intricate production methods, inaugurating an industry unmatched in its versatility and complexity anywhere in the world.

In art the characteristic form of geometric stylization and decoration appeared with the emergence of textile manufacture. In fact, it was probably the technical requirements of textile design that influenced this aspect of Peruvian art, later to be transferred to the decoration of other media. The dependence of early coastal communities on marine resources also influenced the subject matter of their art. Thus, throughout the long history of the pre-Columbian coastal civilizations of Peru, sea creatures were portrayed in art, appearing both as purely decorative elements and as important components of the religious belief systems. It is clear that the unchanging dominance of the sea and its products determined not only the nature of the coastal economy but also the artistic expression and ideological developments of the peoples who lived along its shore.

The Coastal Desert Environment

The entire length of the Peruvian Pacific coastline is bounded by desert. The Peruvian coastal desert plain, a northward extension of the great Atacama Desert of Chile, contains one of the most arid environments in the world. The existence of desert in this tropical region immediately adjacent to the lush coastal jungles of Ecuador may at first seem surprising. Again, the cold Humboldt Current plays a leading role in creating this phenomenon, constituting in combination with distinctive land forms a rare geoclimatic pattern which determines the nature of human life along the coast. The coastal plain is narrow, rarely exceeding 50 kilometers in breadth except in the north, and bounded and visually dominated in the east by the great upthrusting wall of the Andes, the almost sheer slopes of which soar abruptly to an average elevation of over 3,000 meters. The Pacific trade winds are cooled as they blow over the Humboldt Current, then warmed when they reach the tropical land mass. Consequently, the thick clouds formed over the cool ocean have their moisture-bearing capacity enhanced by onshore warming until they come into contact with the cooler high elevations of the Andes. Here precipitation occurs, leaving the intervening plain rainless and arid. However, the rain thus deposited on the mountains does ultimately offer an abundant life-sustaining source. More than fifty small rivers generated on the Pacific mountain slopes flow down to the plain, then across the desert back to the sea. In their desert courses these rivers provide the basis for an agricultural irrigation technology that has been refined to such a degree that it has supported a long succession of complex civilizations.

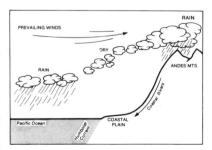

Schematic cross section of the Peruvian coast with marine, topographical, and climatic conditions.

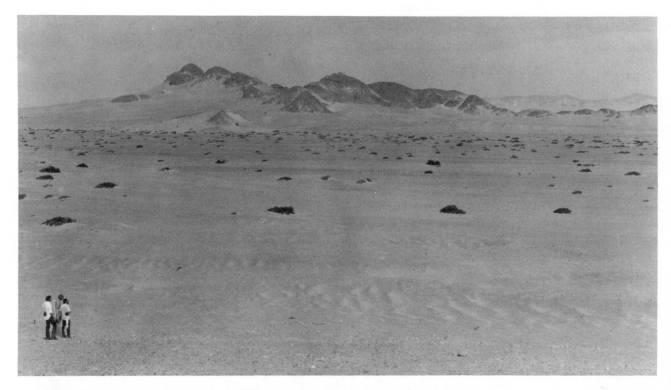

Along the Peruvian coastal plain, canal systems, originating at the points where the rivers debouch from their mountain courses, spread out like great fans across the desert floor, bringing water to all available agricultural ground. These hydraulic systems, which date back to the early second millennium B.C. and which required vast outpouring of labor and great refinement of technological skill for their construction and maintenance, reached the apogee of their development just prior to the Spanish conquest. Since then they have declined, leaving only vivid reminders of their earlier extent in the great areas of abandoned fields that extend along the coastal valley fringes. Agriculture practiced in these coastal valley systems produced a profusion of crops. The staple subsistence foods, maize, beans, and squash, were supplemented by a rich variety of tropical fruits and vegetables. Indeed, these artificially created and constructed valley environments, complemented by the harvest of the nearby ocean, were capable of producing virtually the entire spectrum of tropical South American crops. The valleys were thus substantially self-sustaining.

Within this largely consistent subsistence environment there were, of course, variations caused by geographical fluctuation. The rivers of the northern Peruvian

The Peruvian coastal desert north of the Cupisnique Quebrada.

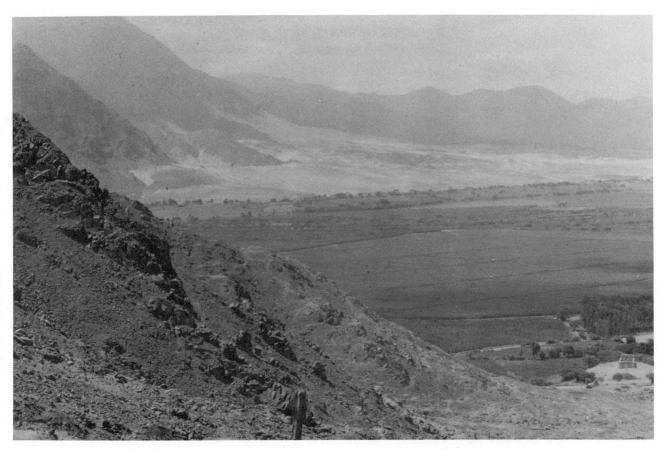

Andes foothills at the neck of the coastal Moche Valley with intensively irrigated agricultural land and flanking desert.

coastal desert are generally of greater volume and run through wider cultivated valleys than those farther south. In several places on the north coast the relatively level character of the coastal plain allowed the linking of several rivers, by means of huge intervalley canals, into wide hydraulic complexes capable of sustaining intensive urban populations and large cities and providing the economic basis for major political development. This type of integration was less possible on the south coast where rivers are smaller and often run through deeply indented courses, thus sharply limiting their potential for irrigation use.

As in the situation with the maritime settlements, the coastal desert with its intermittent succession of valley oases exerted a strong influence on the material culture of the area. The cities were largely constructed of mud bricks derived from the banks of the rivers that gave these cities existence. Moreover, the art of the region portrayed many of the valley crops and wildlife while the ever-present and

looming dominance of the Andes was reflected in numerous religious representations. Again, the natural phenomena that allowed life in this desolate area and placed physical limits on its potentials played a prominent role in the aesthetic and religious patterns of the people who lived there.

The Highland Environment

The Andes cordillera, a complex series of generally parallel ranges, is one of the most recently formed mountain chains in the world. Paralleling the Pacific coast and running the entire length of the South American continent, the Andes are a vast barrier separating the narrow arid coastal plain and the limitless tropical forest of Amazonia. The Peruvian Andes present a varied highland topography. Lower in the north, the main Andean ranges are interrupted by smaller east-west oriented formations that break up the high mountains into a series of relatively small sierra plateaus and deep river basins. These northern mountain enclaves are warmer and wetter than the southern Andes and provide ample arable land for human cultivation. The punas, high grasslands above the limits of agriculture, are the home of the Andean camelids, the llama and alpaca.

Farther south the chief Andean ranges separate, are of greater elevation, and are less interrupted by subsidiary mountain chains. Thus, the sierra basins are progressively larger and higher until south of Cuzco, where they merge into a great high plain, the Altiplano. This plain, lying above 3,000 meters, includes all of southern mountainous Peru and incorporates the extensive Lake Titicaca Basin stretching into Bolivia. Colder and drier than the northern sierra, much of the Altiplano is a desolate steppe. However, in the lower altitudes agriculture is possible, and the natural camelid habitat extends throughout the area.

Food production potential in the cold high elevations of the Andes is very different from that of the coastal plain. Subsistence in the Altiplano is based on the narrow range of crops that thrive at an altitude in excess of 3,000 meters, chiefly potatoes, other tubers, and quinoa. In the somewhat lower sierra of the north, a wider variety of crop cultivation is possible. Nowhere is it possible to produce the broad range of subsistence crops that flourish in the valley oases of the tropical coast. However, in pre-Columbian times herding of llama and alpaca was practiced throughout the highlands but only in a limited amount on the coast. On the technological level, the precipitous nature of highland terrain necessitated construction of extensive stone-faced terrace systems to retain arable ground for cultivation. Thus, agricultural potential in the highlands was greatly limited by nature. It evolved a distinctive technology for its fulfillment and required supplementation from other necessary nutrients brought from lower elevations.

Harsh though the Peruvian highlands are, they were the homeland of several magnificent civilizations. The smaller basins of the northern sierra tended to be isolated from each other and, though intensively occupied, appear not to have

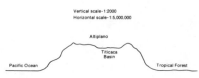

Schematic sections across the northern Andes (top) and the southern Altiplano (bottom).

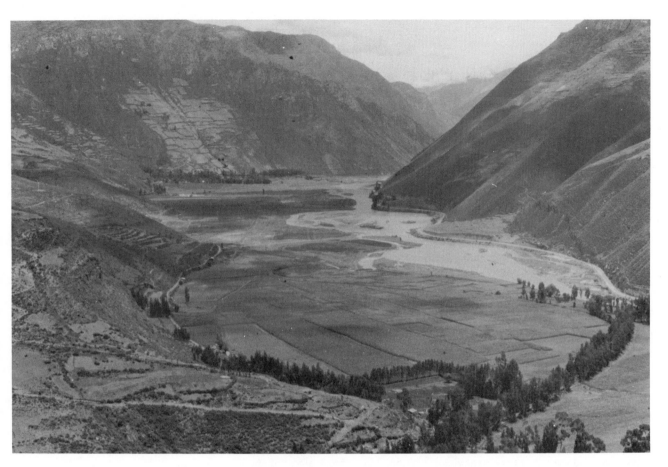

The Urubamba River basin near
Ollantaytambo, southern highlands.

developed widespread political unification. However, in the south the Altiplano
with its easier communication experienced a succession of large territorial poli-
ties. The great city of Tiahuanaco near Lake Titicaca, built like all highlands sites
of mountain stone and centered around an impressive ceremonial complex,
became the focus of a southern Altiplano polity about A.D. 500. Subsequently, this
tradition of southern highland political unity continued with fluctuating territo-
rial configurations to culminate in the great Inca Empire with its capital at Cuzco.

The art of the highlands, although imperfectly known, appears to strongly
reflect environmental influence on religious beliefs. Not only do Andean condors,
hawks, pumas, camelids, serpents, and other highland life forms frequently appear
as decorative motifs, but their portrayal patterns clearly indicate strong religious
symbolism. As we shall see, felines figure prominently in one of the most wide-
spread religious manifestations yet identified, appearing in sacred context not only

in ceramic art but also in numerous monumental stone carvings throughout the highlands, often in unmistakably religious settings. The symbolic importance of the puma was carried to the extreme by the Inca, who shaped their capital of Cuzco in its form. It is natural, of course, that people living in a harsh environment, where every aspect of their lives, indeed life itself, depends on the idiosyncrasies of nature, should reflect this situation in their religion. Andean religion of the highlands and its artistic expression display realization of this dependent relationship of man to nature and incorporate a propitiatory element, intended to aid continuance of precious crop generation and protection from the all-powerful inconsistencies of the natural environment.

The Jungle Environment

On their eastern slopes the Andes fall rapidly from the grassland puna to the lush tropical forest, which extends high into the foothills. This forest merges with the vast jungle of Amazonia, which blankets more than one third of the South American continent. This selva region offers an entirely different set of subsistence and settlement parameters from those of the highlands and dry coastal areas of Peru. The steep eastern mountain slopes are constantly interrupted by swiftly falling rivers flowing through deeply gouged chasms. Moreover, the mountain terrain incorporates some of the most rugged formations of the entire Andean cordillera. The combination of these topographic features with an increasingly impenetrable forest cover produces a physical environment that is at the same time one of the most abundant of the world's natural food-producing habitats and one of the least hospitable in terms of its potential for supporting settled human occupation.

The forested eastern slopes of the mountians produce the entire spectrum of Andean edibles, largely by natural growth, in contrast with the coastal valley oases where complex irrigation technology is required. From the higher elevations come potatoes and quinoa; the intermediate areas produce maize and beans, while the prolific jungle floor is abundant in tropical fruits and manioc. The region thus represents an important food collection area for populations living in the resource-limited neighboring highlands. However, given the difficulty of extending formal occupation into the equatorial forests, these areas were not directly exploited in pre-Hispanic times by simple settlement and farming as elsewhere. Instead, it is clear that from the earliest times there was active exchange between the civilizations of the highlands and the tropical lowlands farther east. This exchange pattern involved not only an abundance of food items but also materials especially prized for their status value, such as the brightly colored parrot feathers, which appear throughout Peru, fashioned into elaborate works of art. Moreover, it is very probable that elements of early Peruvian religion originally derived from the equatorial forest. The cayman, monkeys, and snakes that appear on monumental

stone carvings from the traditionally designated center of the Chavín religious phenomenon in the later second millennium B.C. are jungle animals and reflect infusion of visual and symbolic meaning from this area into the greater Peruvian ideological systems.

In summary, although the jungle environment of the eastern Andean slopes and beyond played an important role in the economic and religious underpinnings of Peruvian civilization, this region remained peripheral in terms of occupation. The civilizations of early Peru were based fundamentally on intensive urbanism incorporating complex social and political organization, patterns that were very difficult to duplicate in the equatorial jungle setting.

Land, Food, and Politics

We have seen that the four components of the Peruvian physical environment — sea, desert, mountain, and jungle — created a world of natural contrasts, with each setting possessing a different food production potential, settlement capacity, and climate from the others. This pattern of environmental diversity was not confined only to the wider sphere but also operated within each physical setting. Thus, the coastal river valleys were broader and longer in the north of Peru, and the intervening desert was regular enough to allow amalgamation of several rivers into large irrigation complexes by means of intervalley canals, a situation not possible in the narrower southern valleys with their smaller entrenched rivers. Similarly, the northern sierra was broken up into relatively small basins separated from their neighbors by mountain ranges. This contrasts with the southern topography, where the great high plateau, the Altiplano, encompassed much of southern Peru and projected quite close to the coast. This accumulation of local and regional geographical diversity exerted a determining pressure on the ecology of pre-Columbian Peru, touching aspects of subsistence, economy, settlement, and politics.

The fundamental dichotomy in the Peruvian physical world was that between highland and lowland. On the level of the individual, this dichotomy necessitated very different life-styles suited either to the high mountain climate or the environment of the tropical lowlands. Houses in the rainy, cold highlands were substantially constructed of stone with high-pitched roofs to ward off rain and were located in areas of good drainage. On the dry coast, however, comparatively flimsy cane-walled dwellings, often with flat roofs, sufficed because of few drainage requirements. More important here was the location of coastal settlement relative to agricultural land. Towns and villages were thus largely placed beyond the limits of irrigable terrain so that every precious portion of the limited agricultural land could be utilized.

More important, the highland-lowland dichotomy embodied contrasting subsistence potentials that were influential in molding the shape of wider eco-

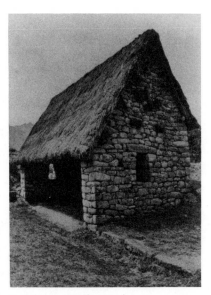

Inca house, Machu Picchu.

nomic and political organization. The rugged mountains with their high plateaus, steeply sloping sides, and deep river valleys comprised a series of contiguous but diverse food-producing enclaves, each with its particular subsistence pattern. This subsistence ladder commenced with llama herding in the high grasslands, then descended to the upper agricultural levels above 3,000 meters, where tubers were produced, down through successively lower crop-specific levels, to the lowest foothills adjoining the equatorial jungle in the east and the coastal plains to the west, where tropical fruits and cotton grew in profusion.

Highland subsistence techniques were perfectly adapted to this vertical food-production pattern. Most land was communally owned by highland villages, and this property was scattered through the various subsistence habitats. A single family could conduct llama herding in the high punas, potato cultivation on the plains below, and maize production on the lower slopes, all within a day's walking distance from their home village. However, the need for commodities native to the coastal foothills such as fruits and cotton encouraged the extension of this pattern. Thus, highland villages often maintained food-production rights over satellite settlements in the lower areas from which members of their community obtained items unavailable to the parent village. This unique response to a complex environment led to two important results. First, food commodities were under direct control of the village farming class from production to consumption, thus obviating the need for a merchant or trading class. In this system, Peru was unique among the world's early civilizations. Second, because of this subsistence pattern the highland populations were predisposed to reach downward to the lowlands to fulfill vital nutritional needs. This tendency was greatly in evidence in the south, where the mountain plateaus were large and relatively unbroken, supported greater population levels, and reached close to the sea. In fact, it appears that this basic subsistence-derived expansion stimulated wider cultural connections with religious and political unification following and overshadowing the limited downward extension of village economy. Farther north, the highlands were broken into smaller more isolated basins and adjoined the wide coastal plain, the politico-economic development of which sufficed to resist their downward thrusts. Thus, unification of coast and highland was less pronounced in the north than in the south.

As we have mentioned, the coastal plain posed its own set of ecological parameters for human social and political development. The numerous river valleys were virtually self-sufficient in food production. Consequently, unlike the highlands, expansion pressures were lateral rather than vertical and served to satisfy food demands of a growing population rather than the need for a basic variety of crops. There was, as a result, no expansion into the highlands, which in many ways formed the inland boundary of the coastal communities' cultural

horizons. Instead, coastal movement proceeded along a lateral axis with neighboring river valleys being combined under central political control into large irrigation complexes able to support intensive populations. However, the intervening desert strips, while not barring the formation of unified states, do appear to have encouraged some cultural isolation; this is indicated by the persistence of very different local art styles in adjacent valleys along the coastal plain. Thus, this region produced extensive political states paralleling the Pacific shores, which in the north incorporated coastal cultural diversity while repulsing the downward grasp of the highlands until the time of the Inca.

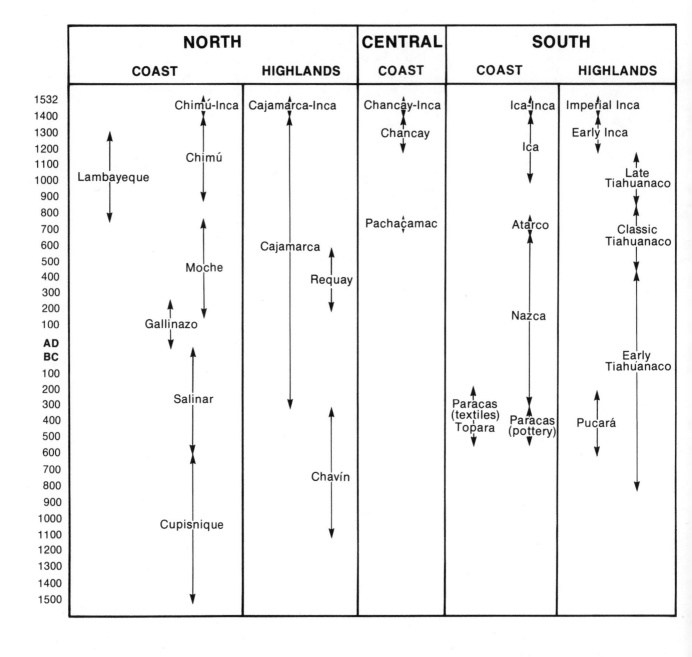

	NORTH		CENTRAL	SOUTH		
	COAST	HIGHLANDS	COAST	COAST	HIGHLANDS	
1532		Chimú-Inca	Cajamarca-Inca	Chancay-Inca	Ica-Inca	Imperial Inca
1400				Chancay		
1300						Early Inca
1200			Chimú		Ica	
1100						
1000	Lambayeque					Late Tiahuanaco
900						
800						
700				Pachacamac	Atarco	Classic Tiahuanaco
600			Cajamarca			
500			Moche			
400			Requay			
300						
200					Nazca	
100		Gallinazo				
AD						Early Tiahuanaco
BC						
100						
200						
300		Salinar		Paracas (textiles)	Paracas (pottery)	Pucará
400				Topara		
500						
600						
700			Chavín			
800						
900						
1000		Cupisnique				
1100						
1200						
1300						
1400						
1500						

From Paleo-Indians to Pizarro: Peruvian Prehistory

Peruvian prehistory is, at present, a fragmentary tale. After more than a century of investigation, the archaeological record remains highly uneven — fairly detailed for some places, times, and topics; virtually nonexistent for others. Nonetheless, cumulative research has gradually provided us with a basic understanding of Peruvian cultural development. Here we can only summarize the long and complicated story of myriad individual societies, each rising and falling in its turn but together forming an unbroken cultural tradition that persists to this day.

The First Inhabitants
(Preceramic Period II: 10,000–7000 B.C.)

We call the first inhabitants of the Americas "Paleo-Indians." They were descended from people who crossed the Bering Land Bridge between Siberia and Alaska during the Wisconsin Glaciation, the last ice age. We do not know exactly when they arrived in the New World or when they reached South America, but their first definite traces in Peru appear around 10,000 B.C.

Only a few Peruvian sites and cultures have yielded acceptable dates in this range, but they occur both on the coast and in the highlands. After about 8500 B.C., sites become more numerous and the evidence much more extensive. Most known Paleo-Indian artifacts are stone tools, but occasional finds of bone tools, wooden implements, and even basketry testify to a much richer inventory.

Not too long ago our picture of the Paleo-Indians was one of nomadic big-game hunters pursuing now-extinct Ice Age mammals. To be sure, Peru's first peoples did stalk some large and dramatic prey — sloths as big as elephants, armadillolike creatures the size of rhinoceroses, and so forth. However, recent investigations portray the Paleo-Indians as more eclectic hunter-gatherers. They lived in small groups and exploited a wide range of plants and animals, tailoring their diet to the foods available at any given time of the year. Furthermore, the evidence at hand suggests that by 10,000 B.C. most of Peru's Paleo-Indian groups were following a well-defined seasonal round, confining their wanderings to fairly limited territories with which they were highly familiar.

Two developments of the later Paleo-Indian era (8500–7000 B.C.) were particularly significant. First, on Peru's north coast certain groups were making use of the rich shellfish beds along the shoreline. This step marked the beginning of

Time chart of pre-Columbian archaeological cultures of Peru.

the maritime economy that would underwrite the earliest Peruvian coastal civilizations. Second, at Guitarrero Cave in the northern highlands, Peru's first known cultivated plants appeared: chili peppers and kidney beans around 8500 B.C., and several others, most notably lima beans, by 7000 B.C. These initial domesticates were not of surpassing importance to the cave's inhabitants; they were simply new plant foods worked into the established seasonal round. Yet, an unimpressive handful of beans and peppers dated to 8500 B.C. constitutes our first glimpse of the agricultural economy upon which all of Peruvian civilization would eventually depend.

The Origins of Agriculture
(Preceramic Periods III–V: 7000–3500 B.C.)

Our knowledge of early Peruvian agriculture is currently hampered by an imbalance in the data. The most complete sequence of domesticated plants and animals comes from the arid coast, where normally perishable materials are excellently preserved. However, the majority of the domesticated plants and animals of ancient Peru have their wild ancestors in the highlands or in the tropical rain forest east of the Andes, where the likelihood of preservation is much less. In fact, while the earliest known domesticates have been found in the highlands, the species involved are probably native to the tropical forest. In recent years the idea that South American agriculture actually began in the eastern lowlands has been gaining increasing acceptance. Stated in full, the argument is impressively logical, but it lacks hard supporting evidence. Nothing is more difficult to find than a 10,000-year-old plant in a jungle.

Hence we will confine ourselves to the highlands and coast. In the mountains the process first seen at Guitarrero Cave — a gradual incorporation of cultivated plants into the seasonal round — continued during the period from 7000 to 3500 B.C. The most detailed highland sequence, that of the Ayacucho Basin in south-central Peru, is flawed and not incontrovertible. Nonetheless, it seems that before 4000 B.C., the bottle gourd, squashes, several kinds of beans, and cotton were added to the Ayacucho economy. Corn, one of the staples of later Peruvian diets, may have appeared about 4000 B.C. None of these plants was first domesticated in the Ayacucho region, and their precise origins remain unclear. Other highland staples, such as the potato and the llama, were probably first domesticated in the Titicaca Basin, perhaps during this period, although direct evidence is still lacking.

In general, the highland picture is one of a slow, steady build-up to a fully agricultural way of life. As domesticated plants and animals became increasingly important to the mountain peoples, seasonal rounds had to be rescheduled. Social groups became larger and increasingly tied to specific locations. Still, this trend was gradual, and the first sedentary agricultural villages were not established until the middle of the next period, after 2500 B.C.

The coastal story is somewhat different. We know it best from the central coast in the vicinity of modern-day Lima. Here heavy winter fogs (June to October) contain enough moisture to support scattered patches of vegetation known as *lomas,* which flourish within a few kilometers of the shoreline. Some of the plant species in the *lomas* are edible, and deer forage there. Both the plants and the deer made the *lomas* attractive to early Peruvians.

By 7000 B.C. the peoples of the central coast had developed a seasonal cycle of winter hunting and gathering in the *lomas* and summer camps farther up the coastal river valleys. This way of life persisted with little change until shortly after 5000 B.C., when new foods began to appear in the winter diet. Specifically, mollusks and small fish began to replace deer as the main source of animal protein, and the first domesticated plants — bottle gourds and squashes — were introduced. People began to abandon the old *lomas* sites and to spend their winters in camps about halfway between the *lomas* and the shoreline. By 3500 B.C. the new way of life had become traditional.

The reasons given for these changes are controversial. Some scholars postulate a climatic shift that reduced the area of *lomas* bloom, while others suggest a need to feed a growing coastal population. We tend to side with those archaeologists who argue that the new foods were adopted simply for the sake of variety and that population growth was a result, not a cause, of their introduction. Whatever the reason, in their turn to the sea, the peoples of the central coast were setting the stage for the emergence of Peruvian civilization.

The Rise of Complex Society
(Preceramic Period VI—Initial Period: 3500–1500 B.C.)

The period from 3500 to 2300 B.C. witnessed radical changes on the central coast. Rapid population growth was accompanied by a shift to heavy dependence on marine foods. (Again, the question of cause and effect is hotly debated). The old seasonal cycle was abandoned, and people settled in permanent towns and villages along the shore. The rich resources of the inshore waters could support large populations, and some of the bigger towns had several thousand inhabitants.

All of these central coast settlements were characterized by developing social and political complexities, which one investigator has termed "the foundations of Peruvian civilization." Some individuals, and perhaps even whole communities, began to specialize in certain crafts. The results were the first masterpieces of Peruvian art, most notably in the form of cotton cloth. These early textiles, lavishly decorated and full of meanings we have yet to decipher, established a tradition that would last to the Spanish conquest and beyond.

Marked differences in burials, and in particular the elaborate graves of certain infants, bespeak the beginnings of hereditary social inequality. For the first time in Peruvian prehistory, social status came to be determined by birth, not

24

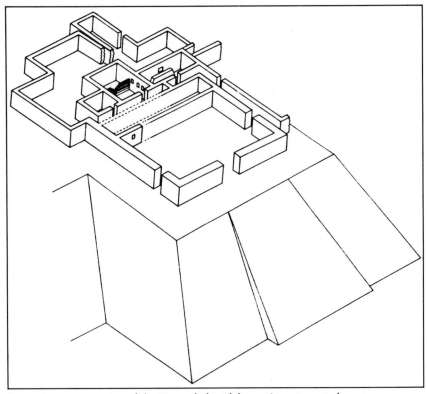

Isometric reconstruction of the Huaca de los Idolos at Aspero, central coast.

achievement. Burial customs also reveal one of the basic forms of Peruvian religion, cults of the dead, in which the spirits of the deceased were believed to play major roles in the world of the living.

A number of central coast sites, such as Aspero and El Paraíso, contain impressive public buildings, flat-topped pyramidal mounds, and sprawling groups of conjoined rooms. We call such structures "corporate labor architecture," that is, architecture built by construction crews drawn from multiple households or communities and directed by some kind of higher authority. The magnitude of these corporate projects testifies to the growing power of local political and religious leaders.

Only a few contemporary highland sites, all of them in north-central Peru, have corporate labor architecture. The best-known examples are La Galgada and Kotosh. Apparently, neither site had a large resident population, and the settlements of the people who supported them have yet to be found. Furthermore, the scale of their public buildings does not match that of their coastal counterparts. Nonetheless, they do reflect social developments paralleling those of the central

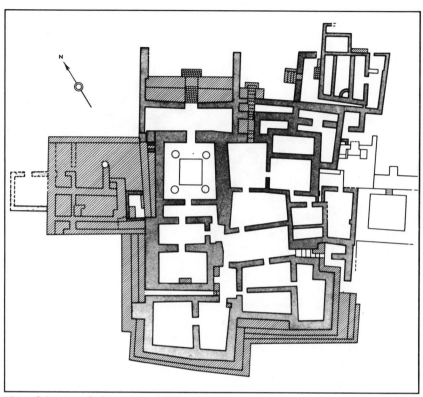

Plan of the site of El Paraíso, Chillón Valley.

coast, but presumably based on increasingly productive agriculture. Outside of the north-central region, life in the mountains seems to have gone on much as before.

During the centuries from 3500 to 2300 B.C., new domesticated plants, mostly of highland origin, were added to the coastal diet. Around 2500 B.C. the cultivation of corn was introduced. Still, for the time being coastal economies remained oriented toward the sea.

The next round of major cultural changes occurred between 2300 and 1500 B.C. At the onset of this period, the 6,000-year-long transition to economies based on intensive agriculture was finally completed. In the highlands the earliest known permanent villages were founded. The focus of coastal settlement shifted inland to the upper reaches of the river valleys, and the first irrigation networks were constructed. Simultaneously, the first local pottery styles appeared throughout most of the country, with the exception of the far south. Corporate labor construction spread northward beyond its previous limits, and Peru's first monumental stone sculpture was erected at the site of Cerro Sechín on the north-central coast. Peruvian civilization was primed for its first great florescence.

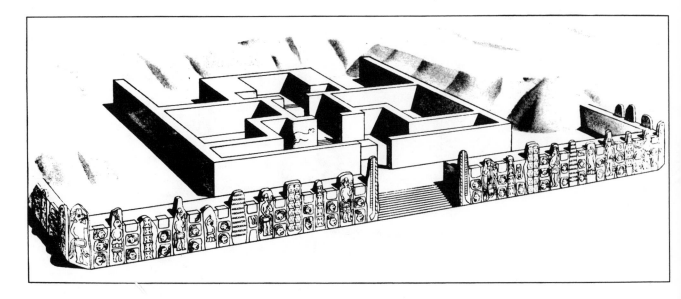

The First "Unification"
(Early Horizon: 1500–300 B.C.)

Reconstruction of the temple
of Cerro Sechín, Casma Valley.

By 1500 B.C. the complexity of Peruvian life had increased to the point where we can identify a number of regional cultural traditions, each with its own art style, religious beliefs, and political sphere of influence. Although these cultures were distinct from one another, there were regular contacts among them. Beginning about 500 B.C., their interaction brought about the first great episode of unification in Peruvian prehistory, the Early, or "Chavín," Horizon.

The hallmark of the Early Horizon is an elaborate art style emphasizing felines, humanlike beings with feline attributes, birds of prey, serpents, etc. Elements of this style eventually spread throughout much of Peru, excluding the far south, and they were portrayed in a variety of media — pottery, goldwork, painted friezes, textiles, and so on. The most spectacular manifestations were the monumental stone sculptures of Chavín de Huantar in the northern highlands.

Until recently the Early Horizon was interpreted as reflecting the spread of a single major religious cult. New data show, however, that this view exaggerates the unity of Early Horizon art. In each of the regions where it is found, the style is expressed in different ways. Only a few motifs were widely diffused (except toward the end of the period), and the "mythical beings" that were portrayed varied from place to place.

There is another problem with the idea of a single homogeneous cult: it

implies a single source for the events of the Early Horizon. Archaeologists have never been able to agree on where that source lay; the coast, the highlands, and the tropical forest have all had their proponents. The most popular choice was the highlands, and specifically the site of Chavín, where the art style was most fully developed.

However, recent work has contradicted this interpretation. The unifying forces of the Early Horizon began on the coast, but not in any single location. Around 1500 B.C. a series of important religious centers — Garagay, Las Haldas, Huaca de los Reyes, and others — were erected virtually simultaneously along the central to north coasts. The first major highland center, Pacopampa, was not built until around 1200 B.C. Chavín itself was not founded until about 1000 B.C. and did not reach its height until between 600 and 300 B.C., when true Chavín influences spread throughout the highlands and onto the south coast. By this time the Early Horizon movement had run its course in its coastal area of origin, and the regional cultures of the north and central coasts were already assuming their post-Early Horizon configurations.

Hence we can no longer think of the Early Horizon in terms of a single cult with a single source. Rather, it was a phenomenon that arose only when a number of cultures in a number of different areas had reached a sufficient level of complexity. Regular contacts among those cultures produced a shared body of ideas. In turn, those ideas were continually reinterpreted as they were worked into the regional religious traditions.

Still, we continue to see the spread of Early Horizon art as religious in nature, and we do not speak of states or empires at this time. Most of the ideas and beliefs involved elude us, but we are gradually obtaining a better understanding of Early Horizon religions. For one thing, their ultimate basis must have been shamanism. Shamans are mediators between the world of men and the world of spirits, religious practitioners who believe themselves capable of traveling between one world and another. They see themselves as being under the protection of certain animal spirits, into which they "transform" themselves, often with the aid of hallucinogenic drugs. Animals and hallucinogenic plants are recurring themes in Early Horizon art.

Another aspect of Early Horizon religion is particularly intriguing. The most widely diffused of the deities from Chavín is a personage known as the "Staff God," a manlike being with snakes for hair, a feline mouth, and an elaborate staff in each hand. He may well have been a sky god with an astronomical basis. If so, he was not like Greco-Roman gods, each of whom corresponded to a specific heavenly body. Instead, he was probably associated with the cyclical movements of the stars and planets. Although the Staff God's original identity is not certain, he does reappear as a major religious figure, a manifold god of sky and storm, in each of the succeeding epochs of unification.

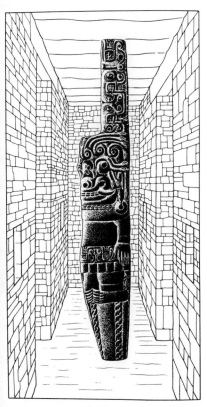

The monumental stone sculpture "The Lanzón," Chavín de Huantar.

States and Cities
(Early Intermediate Period: 300 B.C.–A.D. 550)

The period from 300 B.C. to A.D. 550 has a number of salient features. First, out of the Early Horizon base there arose a series of brilliant regional civilizations, Gallinazo, Moche, Lima, Nazca, Cajamarca, Requay, Pucará, Tiahuanaco, and others. Together they constitute the golden age of Peruvian art. Later cultures would outstrip them in size, political power, and technological sophistication, but the artistic achievements of the Early Intermediate Period would remain unsurpassed. Several of these regional civilizations figure prominently in this exhibit, and they are discussed in more detail in subsequent sections.

Some of these cultures fulfill the archaeological criteria for state-level organization, and they represent Peru's first political states. The most notable of these early states was the Moche culture of the north coast (A.D. 150–750). Its capital lay at the site of Moche in the valley of the same name. The site is dominated by two flat-topped pyramidal mounds, the Huaca del Sol and Huaca de la Luna (Pyramid of the Sun and Pyramid of the Moon; the names are of post-conquest origin). Made with millions of sun-dried mud bricks, the Moche pyramids rank among the largest corporate labor projects ever undertaken in the New World.

At its height, from about A.D. 300 to 600, the Moche state was 300 kilometers long and encompassed nine coastal river valleys. The first multivalley irrigation networks were probably built by the Moche state. Each of its subject valleys contained one or more major administrative centers built according to the architectural canons of the capital. Each major center was surrounded by a series of lesser centers and settlements, all of them contributing to the support of the state and its rulers.

All of the state's corporate labor projects — the Moche pyramids, provincial administrative centers, canal networks, etc. — were undertaken through what we call "labor taxation." Citizens paid their taxes in the form of labor, not goods, and were required to contribute a certain amount of work to the state each year. In return, the state had a variety of obligations to its citizens. To fulfill these obligations and to support itself, the state owned vast areas of agricultural land, which its taxpayers were required to cultivate. This system of taxation and of reciprocal obligations between state and citizen, which had its roots in the mutual duties of village kinsmen, would characterize all subsequent Peruvian states.

Most of the neighboring states were neither as large nor as powerful as Moche. However, they did share one common characteristic with Moche civilization: their principal administrative centers were Peru's first true cities. The origins of urban life in Peru were intimately linked to the rise of states, and the earliest Peruvian cities were rather different from their counterparts in the Old

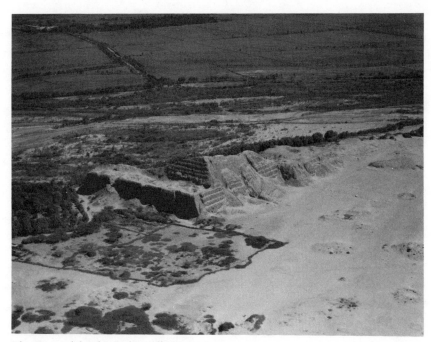

The Huaca del Sol, Moche Valley.

World and Mexico. We might call them "empty" or "artificial" cities in the sense that their permanent populations consisted entirely of official personnel — civil and religious administrators, craftsmen producing goods for state purposes, and so on. The taxpayers who supported them — farmers, herders, and fisherman — lived elsewhere. In subsequent epochs this pattern of artificial cities would prevail whenever state structures were strong. More diversified, self-supporting cities arose only when Peruvian states were weak.

The Early Intermediate Period witnessed one other event of paramount importance: the emergence of the Titicaca Basin as the principal focus of highland civilization. During this time two sites attained positions of eminence, Pucará in the northern part of the basin and Tiahuanaco in the south. Both were originally settled in the latter half of the Early Horizon, between approximately 800 and 600 B.C., and they established contacts with the south coast early in their histories; but neither became truly powerful until the Early Intermediate Period. Tiahuanaco eventually eclipsed Pucará and began to extend its influence into southernmost Peru and much of Bolivia around A.D. 450. The exact causes and nature of the initial Tiahuanaco expansion are unclear, but they formed the background for the next major episode of unification.

The Second "Unification"
(Middle Horizon: A.D. 550–1000)

The second epoch of pan-Peruvian cultural ties is known as the Middle Horizon. It was a period of widespread change marked by the temporary preeminence of the southern highlands. Many of the previous regional civilizations, such as Moche, Requay, and Nazca, persisted into the first part of the Middle Horizon, until A.D. 600 or 700, and then collapsed or were transformed in ways that are not yet clear.

Everyone agrees that the impetus for Middle Horizon "unification" ultimately came from Tiahuanaco. That site was the source of elaborate and highly distinctive styles of pottery and stone sculpture. During the Middle Horizon, a series of related styles, usually expressed in ceramics or textiles, carried elements of Tiahuanaco art throughout much of Peru. Tiahuanaco influences were particularly strong in the southern highlands and on the south and central coasts. The art styles of Pachacamac on the central coast, the south coastal Ica and Nazca valleys, and Huari in the south-central highlands are directly derived from Tiahuanaco.

Foremost among the designs carried by Tiahuanaco-related art was a being known as the "Gateway God." He had first appeared during the Early Intermediate Period at Tiahuanaco, where he was depicted on the so-called "Monolithic Gateway" or "Gateway of the Sun," a massive arch carved from a single block of stone. A standing figure with serpentine hair, "weeping" eyes, and a staff in each hand, the Gateway God is clearly a direct descendant of the old Chavín Staff God. This time, however, we are more certain of his identity: he was a manifold celestial deity who was simultaneously the creator of the world, the embodiment of the cyclical movements of the stars and planets, a god of sky and storm, and a culture hero. At the time of the Spanish conquest he was still being worshipped in the Titicaca Basin under the name of Thunupa.

Beyond these facts the Middle Horizon is one of the most confusing and poorly understood periods in Peruvian history. The mechanism underlying the spread of Middle Horizon styles is problematical. Archaeologists once spoke of a "Tiahuanaco empire" but eventually dropped the idea in favor of a peaceful religious diffusion. More recently, scholars have argued that religious ideas from Tiahuanaco were carried outward by a militaristic empire based at Huari in the Ayacucho Basin.

There are some serious flaws in this theory. For one thing, the provincial administrative centers of the "Huari empire" have been devilishly elusive, and none have been found outside the immediate vicinity of Huari itself. For another, outside of the southern highlands pure Huari pottery is relatively rare and almost never occurs in habitation sites or village refuse dumps. Outside the core area, virtually all Peruvian artifacts with Huari-Tiahuanaco artistic elements have been

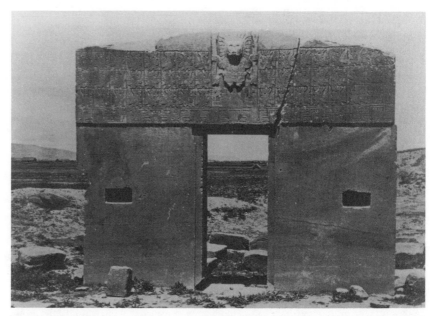

The Gateway of the Sun, Tiahuanaco, with the Gateway God over the gate opening.

found in cemeteries or offertory caches. Finally, the most widespread cultural change of the Middle Horizon was a shift in burial patterns.

All in all, the Middle Horizon is beginning to look much like the Early Horizon. Middle Horizon cultural unity has been greatly exaggerated, and we should probably think in terms of a series of regional states or spheres of influence centered on sites or districts such as Tiahuanaco, Huari, Pachacamac, Cajamarca, Nazca, and so on. If there was a Middle Horizon empire, it was based at Tiahuanaco, not Huari, and it expanded southward into Bolivia, not northward into Peru. Such homogenization as did occur in Peru was essentially religious. It reflected the intensified interaction among independent regional polities, and it was brought about by pilgrims and traders, not imperial armies.

Throughout most of Peru the unifying forces of the Middle Horizon broke down about A.D. 800, and previously large spheres fragmented into small cultural units. However, in the far south Tiahuanaco itself remained strong, and isolated Tiahuanaco colonies were established on the far south coast during the period from A.D. 800 to 1200. These colonies testify to the economic pattern of "verticality" described earlier. Tiahuanaco was finally abandoned around A.D. 1200, and the Titicaca Basin became divided among mutually antagonistic petty states.

Conflict and Empires
(Late Intermediate Period: A.D. 1000–1475)

The peoples encountered by Peru's Spanish conquerors emerged out of the turmoil left by the breakdown of the Middle Horizon and the eventual collapse of Tiahuanaco. The story of the Late Intermediate Period is one of conflicts among a multitude of small tribes and kingdoms. In turn, two peoples, one coastal and one highland, rose out of this competition to subjugate their neighbors and establish Peru's late prehistoric empires.

The first of these great powers was the Chimú empire of the north coast. The heirs of the old Moche civilization, the Chimú, appeared in the archaeological record between about A.D. 850 and 900, but remained inconsequential for several centuries thereafter. They did not begin their imperial expansion until about A.D. 1200, whereupon their domain grew continuously until they were finally defeated in about A.D 1465. At its height the Chimú empire encompassed the northernmost 1,000 kilometers of the Peruvian coast, from the Ecuadorian border to the outskirts of modern Lima.

The Chimú capital, Chan Chan in the Moche Valley, is the largest archaeological site in South America, and its ruins sprawl over twenty five square kilometers. Despite its great size, Chan Chan was a typically "artificial" Peruvian city occupied solely by state personnel, and it probably had only 25,000 permanent residents. (Should this number seem large, the ancient city of Teotihuacan, Mexico, covered about the same area as Chan Chan but had four to eight times the population.) Central Chan Chan is dominated by ten huge, high-walled compounds, which were the palaces of the Chimú kings. Around the palaces lie lesser courts and compounds, which housed the empire's leading administrative officials. The bulk of Chan Chan's population consisted of skilled craftsmen — potters, metalworkers, woodcarvers, and so on — who toiled under state supervision and lived in humble houses made of canes and reeds.

Throughout the empire a hierarchy of administrative centers and settlements attested to Chan Chan's power. On a grander or lesser scale, each provincial administrative center copied the appropriate architectural features of the imperial capital. All of these sites lay on the coast, for, like other coastal states, the Chimú empire never attempted to incorporate mountain territory within its boundaries. Instead, the Chimú were content to maintain a military alliance with the small but vigorous highland kingdom of Cajamarca.

Chimú society was highly stratified, and there were marked differences in social and political standing. The Chimú kings were held to be gods, and they retained all of their property and privileges after their deaths. That is why there are ten palaces in Chan Chan, since each king had to build his own. All of the previous palaces were still owned by corpses.

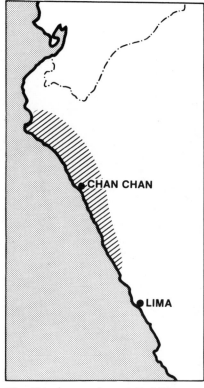

The Chimú state, about A.D. 1460.

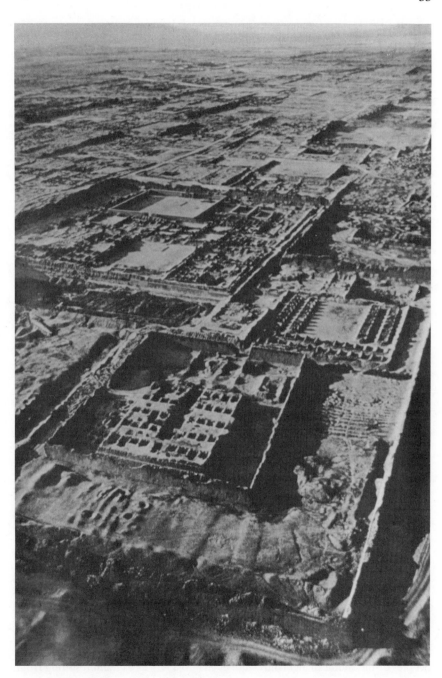

Aerial photograph
of Chan Chan, Moche Valley.

Ancient fields near Chan Chan on the northern Peruvian coast.

Below the rulers came the nobility, who held all of the positions in the civil, religious, and military administrations. Skilled craftsmen had less prestige but still ranked high enough to be full-time specialists, exempt from normal taxation. At the bottom of the pyramid lay the peasant farmers and fishermen who formed the vast majority of the empire's subjects. So rigid were these distinctions that the nobility and commoners were believed to be the products of separate creations.

At the heart of Chimú religion lay the ancient Peruvian cults of the dead. The continuing wealth and power of deceased kings were simply the most spectacular expressions of a more widespread pattern of ancestor worship. Besides the spirits of the dead, important religious figures included the sea and the moon. One of the most sacred sites in the empire, Pacatnamú in the Jequetepeque Valley, was the focus of pilgrimages dedicated to the veneration of the moon.

All of this cultural elaboration rested upon the traditional system of labor taxation and upon a fantastically productive agricultural economy. The Chimú were masters of hydraulic engineering, and they built extensive irrigation networks. In one case they even succeeded in linking five separate river valleys into a single agricultural complex. Their skill was so great that in A.D. 1450 there was forty percent more land under cultivation than there is today.

Meanwhile, at the opposite end of the country, the historically documented peoples of the southern highlands were born into a power vacuum resulting from

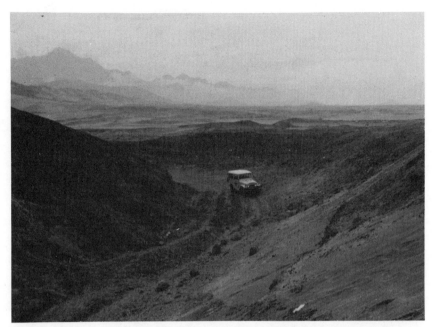

Major intervalley canal of Chimú date connecting the Moche and Chicama valleys. (The vehicle is standing on the canal floor.)

the collapse of Tiahuanaco civilization around A.D. 1200. Among these mountain peoples was a small tribal group in the area around Cuzco, north of the Titicaca Basin. In the beginning this latter culture was so unprepossessing that its archaeological remains have been called "exceedingly inconspicuous." Nonetheless, about A.D. 1438 it started to prevail in the fierce infighting of the southern highlands, and by A.D. 1475 it had conquered most of Peru, including the once-mighty Chimú empire. This upstart group was the Inca, and we have given their name to the largest empire ever formed in the Americas.

Tawantinsuyu
(Late Horizon: A.D. 1475–1532)

The Incas themselves called their empire "Tawantinsuyu," or "Land of the Four Quarters." It was the last great unifying force of Peruvian prehistory, and it pushed the frontiers of Peruvian civilization far beyond their previous limits. From the Pasto River in southern Colombia to the Maule River in central Chile, Tawantinsuyu spanned thirty-six degrees of latitude. All of this vast territory was conquered during the reigns of three Inca rulers: Pachakuti (1438–1471), Topa Inca (1471–1493), and Huayna Capac (1493–1525).

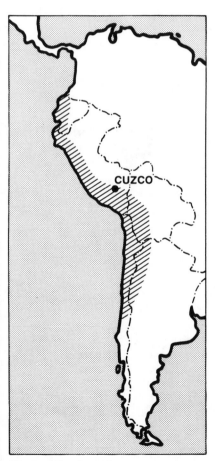

The Inca Empire at its greatest extent, about A.D. 1530.

Cuzco, the Inca capital, was laid out in the shape of a puma. The head was formed by the great fortress of Sacsahuaman, while palaces, temples, other buildings, squares, and streets filled out the puma's body, legs, and tail. Within this sacred city dwelled the Inca emperors, their courts and retainers, the high priests, the prefects of the empire's four quarters, and other officials. Like Chimú rulers, Inca kings were worshipped as gods; in death they retained all of their property, and their mummies were maintained in living splendor.

The Inca rulers established administrative centers in all of their provinces. Some of these sites — Huánuco Pampa, Tambo Colorado, Ollantaytambo, Pisac, and others — rank among Peru's most picturesque archaeological ruins. And how could we neglect to mention Machu Picchu, the famous "Lost City of the Incas" (which was actually more of a religious than a civic center)? The provinces were linked and the entire empire was integrated by a superb network of roads, including the two great highways that astounded the Spanish conquistadors. Relay runners called *chasquis* carried messages along the roads, conveying information up and down the governmental hierarchy. Quechua, the Inca language, was used for all administrative purposes.

Each province was supervised by an imperial governor and a set of hereditary officials known collectively as curacas. Local populations were divided into a series of graded units that in theory were based on multiples of ten, although actual practice varied according to circumstances. In some cases provincial populations were reshuffled, and groups of colonists (*mitmaqkuna*) were resettled, either to minimize the danger of rebellion or to introduce certain crops into areas where they had not been grown before.

One of the chief duties of this elaborate administrative structure was to oversee the empire's system of labor taxation. Citizens paid their taxes by constructing all public works and manning the Inca armies. They also cultivated state-owned farmlands, which were located throughout the provinces and were constantly being enlarged, either by extending coastal irrigation networks or terracing highland hillsides. The produce of these fields was gathered into imperial storehouses and from there it was distributed to imperial retainers to support the state's undertakings.

The Incas had no writing to aid them in their multifarious projects. Instead, census data, economic accounts, and historical records were kept on bunches of knotted strings known as quipus. The color, twist, and position of the strings and the number, type, and spacing of the knots had meanings, but they could be deciphered only by trained interpreters.

Inca religion was highly complex, and it is still poorly understood. The best-known deities were the "sun god" Inti, from whom the Inca rulers claimed to be descended, the "thunder god" Illapa, and the "creator" Viracocha. Despite their different names, they were actually overlapping aspects of one overarching

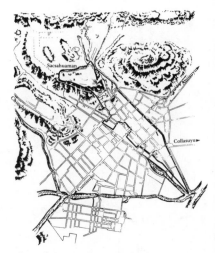

Plan of Cuzco showing the Inca settlement in the form of a puma.

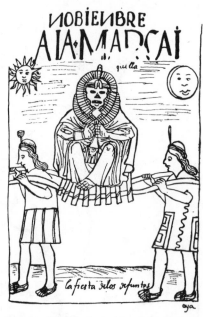

Guaman Poma's depiction of the festival during which mummies of deceased Inca rulers participated in religious ritual.

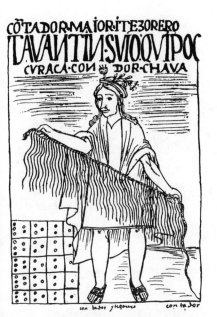

Inca quipu as illustrated by Guaman Poma.

godhead, a manifold sky god based on astronomical movements. No idols of this high god have survived, but the Incas described him to the Spaniards. He looked very much like the old Gateway God of Tiahuanaco, from whom he must have been derived. The Inca imposed the worship of their high god throughout their empire, but otherwise they tended to be tolerant of local beliefs.

In addition to the high god, there were many other Inca deities, all of them integrated into the divine complex in ways that are not yet clear. Another important concept was *huaca,* a generic term for any person, place, or thing with sacred or supernatural associations. In practice, almost anything odd or unusual was held to be a *huaca,* and the Inca world was full of them. Many of them were connected with the spirits of the ancestors, for at the very core of Inca religion was the traditional Peruvian cult of the dead.

For all of its size and splendor, the Inca Empire had a number of internal weaknesses, and they came to the fore upon the death of the emperor Huayna Capac in A.D. 1525. A bitter power struggle between two of his sons, Huascar and Atauhualpa, drew the empire into a disastrous civil war. After several years of savage fighting, Atauhualpa triumphed and declared himself emperor in AD. 1532. He did not enjoy his title for long. On November 16 of that year, at Cajamarca in the northern highlands, his army was slaughtered and Atauhualpa himself taken prisoner by 168 Spaniards under the leadership of Francisco Pizarro. Within the next twelve months, Atauhualpa was executed, Pizarro's men took control of Cuzco, and Peru had a new king — the Holy Roman Emperor, Charles V of Spain.

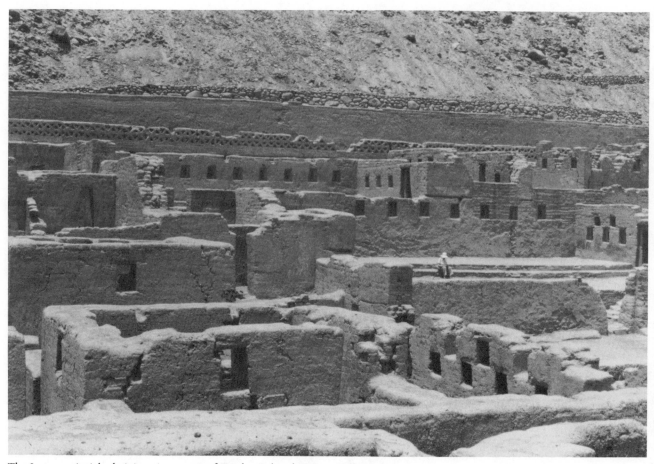

The Inca provincial administrative center of Tambo Colorado, Pisco Valley.

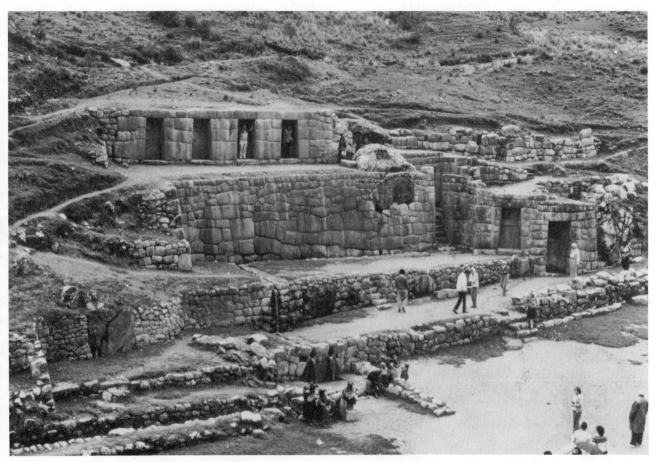

The Inca religious site of Tambomachay near Cuzco.

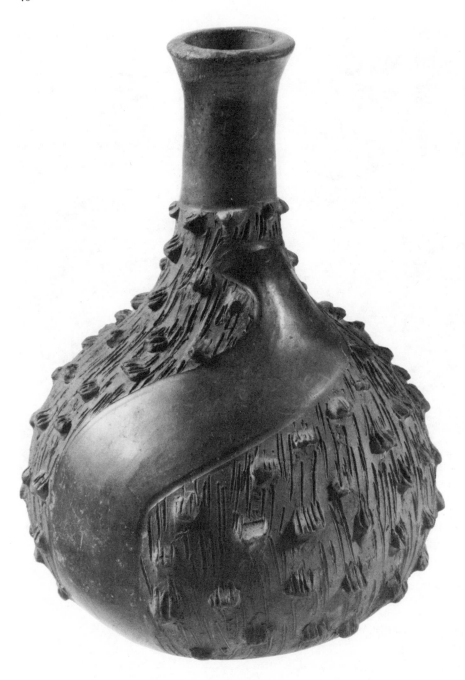

Cupisnique flask.

The Character of Peruvian Art

The Nature of Artistic Dialogue

Works of art, no matter the time or place of their origin, invariably communicate with their viewers. The artist creates a visual pronouncement, whose meaning varies depending on the intended purpose of the finished art object and on a diverse range of natural and human factors. For its viewers the meaning of art derives from the work itself and is molded by their cultural, emotional, and intellectual experience. However, whatever the nature of a particular work of art, the work constitutes a tangible statement which stimulates a reaction from the observer. This visual dialogue is often intentionally precise, both in terms of the art work's statement and the viewer's response. Although it may be easy to interpret this visual language when it occurs within the context of the observer's own culture, it becomes increasingly difficult the greater the time and cultural distance between the observer's society and that which produced the art object. For example, the nature of communication between a religious icon and its owner is understandable within an orthodox Christian society but may be incomprehensible to a society which has no tradition of Christianity and its use of domestic religious art. Similarly, it is difficult for the modern Western viewer to understand the meaning of the visual interchange that transpired between the ancient Peruvian and his art. However, despite such cultural and historical gulfs, a brief examination of the exhibit will make clear to the observer that pre-Columbian art of Peru formed part of a sophisticated and complex artistic dialogue. This dialogue may be appreciated on two levels. First, an unmatched capacity to manipulate the various media reflects a keen awareness of the visual impact to be derived from surface design. Second, the rich content and regular patterning of representational iconography indicate a great capacity for precise communication. This combination of qualities resulted in the creation of an artistic style which shares with all high forms of human artistic expression the ability to transmit important ideas by interpreting them in an aesthetically stimulating manner within strict symbolic parameters. It is clear that the ancient Peruvians understood well the utility of art in facilitating social communication as well as its use for enhancing the quality of the human aesthetic environment.

We have so far discussed the inherent characteristics that pre-Columbian Peruvian art shares with all human artistic expression. Now, we shall examine more closely the influences that molded such expression within the context of a highly complex preindustrial civilization. These influences in Peruvian art, as in all high art styles, ultimately determine the nature of visual comunication and thus

the specific forms of the displayed art objects themselves.

A finished work of art clearly displays its creator's aesthetic conception and technical ability and also embodies a vastly broader range of influences which are not so outwardly apparent. For instance, qualities innate to an art form place formal and conceptual limitations on the artist that are at once universal and clearly definable, determined as they are by the physical composition of the chosen material. Moreover, the physical composition of a work of art and its cultural setting are usually closely related: precious stones and metals are almost always used in works that possess high economic value or denote elevated social standing.

Other factors influencing the character of the art object are more directly attributable to human cultural origins. On a general level, aesthetic taste differs widely among societies separated by geographical barriers and changes significantly through time, even within a single society. More specifically, art objects intended for special uses will always reflect the requisites of these roles. Thus, works produced for religious use carry decoration and iconography unique to their singular ideological meaning. Similarly, works made for trade, political aggrandizement, and household decoration are all shaped in their various ways by the artistic canons associated with these functions and by the time and place of their creation.

In the following pages, we shall briefly explore the character and functions of Peruvian art. By relating the numerous art styles to their total cultural environment, we shall be able to discern the various molding influences exerted upon them by the geographical settings, social contexts, and historical frameworks within which they flourished. More importantly, we should come to a more meaningful understanding of the nature of the visual dialogue between the Peruvian and his art.

Local and Regional Art Styles

Pre-Columbian art of Peru ranks among the world's great aesthetic accomplishments. Expressed through various media, this art incorporates complete mastery of technique and attains rare heights of aesthetic excellence. We shall now briefly discuss the stylistic attributes, technical skills, and artistic variety that characterize Peruvian art, with special reference to the objects represented in the current exhibit.

We have tried to make it clear in the preceding pages that the geographical boundaries of Peruvian civilization can be broadly defined and that the area so circumscribed is extensive and diverse. We have seen that within this vast area natural environment differs sharply from coast to jungle, that ethnic composition was extremely heterogeneous, and that historic development took various courses. This general diversity was intensified on the local level by the distribution of ancient Peruvian populations into somewhat isolated local enclaves — moun-

tain river basins and coastal desert valley oases — each separated from its neighbors by a mountain range or wide desert barrier. Although these physical obstacles were not sufficient to prevent widespread interaction and the ultimate formation of large political states, they do appear to have encouraged the development and persistence of local cultural distinctions.

Art as a product of human cultural personality naturally reflects the major influences exerted on culture as a whole, whether geographical, historical, or ideological in origin. Thus, it is no surprise that the art of pre-Columbian Peru in a general sense exhibits common stylistic and thematic characteristics throughout its territorial span but also displays a wide variety of local variants. Such diversity is largely determined by the same geographical factors that influenced the course of Peru's political evolution. The areas with close natural relationships had a greater tendency to share the same art styles than did those isolated from each other by physical barriers. This general tendency resulted in two contrasting qualities.

First, regional styles developed within the broad geographical components of Peru, especially in those areas that in fact formed discrete physical entities such as the southern highland region and the north coast. Moreover, the strong links between the southern highlands and the south coast, based largely on the greater capacity of the former for political consolidation and the need experienced by highland communities to exploit lower subsistence habitats, led to strong cultural relationships, which are expressed in many shared elements of their art. Conversely, the greater geographical and political separation between the north coast and adjacent highlands was partially reflected in differentiation of their artistic expressions. It must be stated that this is a somewhat simplistic picture of regional artistic diffusion, for art styles did occasionally spread throughout Peru. However, the pattern of shared artistic relationships within the limitations of the wider human ecological context is certainly accurate and helpful in understanding the intricate associations depicted in the current exhibit.

The second important general characteristic of Peruvian art is that of local singularity. Within the broader sphere of human cultural interaction, the communities of each desert river valley and highland basin maintained cultural traits born of their own peculiar needs and adaptation to specific situations. This is a tendency commonly seen in preindustrial peoples today and indeed is still apparent in many modern western countries, where neighboring villages and districts maintain distinctive customs that often include local traditional expressions of their "folk art." While it is now quite difficult to detect such locally defined cultural nuances in the archaeological record as a whole, they are clearly manifested through art. Neighboring valleys, while sharing broad stylistic traits, often maintained distinctive decorative or thematic elements that reflected the aesthetic aspect of their cultural individuality.

Content

The content of art, no matter the time or place of occurrence, is determined by two universal human social qualities: the need to embellish the living environment and the urge to communicate through visual media. These qualities are transferred to the aesthetic sphere in the form of purely decorative designs or symbolic representation. Decorative embellishment may be either totally abstract in form or may depict naturalistic images. In neither case, however, is there any intent to convey specific symbolic meaning. Likewise, art that incorporates intentional symbolic significance need not be overly representational in character. Indeed, most visual language expressed through art embodies some degree of abstraction; however, the form of stylistic abstraction always tightly conforms to the specific symbolic canons of the parent culture and is consequently well understood by its intended viewers. It is sometimes difficult to distinguish between the decorative and symbolic aspects of the art of an unfamiliar society. Nevertheless, even partial definition can shed valuable light on the uses and meaning of art in its cultural setting.

The art of ancient Peru conforms closely to this general model. There is extensive use of design in many media for purely decorative purposes. More important, it appears that art was generally utilized in the many regional and local styles of the area to convey important ideological meanings. Recent analysis has provided much vital interpretive information about the nature of this symbolic communication and allows us to perceive some of the deeper cultural contexts in which it functioned. Thus, it is clear that within the various regions of Peru and occasionally across interregional boundaries Peruvian art played a vital role in those cultural systems that combined to cement social integrity and stability: religion and political authority. Each of the diverse regional art styles, such as those of the Moche and Chimú of the northern coastal region and the Nazca of the south coast, incorporates a strict set of iconographic symbols peculiar to its own region and occurring again and again in rigidly defined contexts. Although it is not possible to identify the precise meaning of these religious design codes, their function can assuredly be related to the universal tendency of human communities to establish officially sanctioned ideological world views.

On the wider level, Peruvian art on at least two occasions in its long history reflected the spread of great interregional religions. The Chavinoid styles of the late second millennium B.C. and the Tiahuanacoid styles of the first millennium A.D. both accompanied such phenomena. These styles are characterized by quite specific religious designs, which are incorporated into the various regional styles, superimposing on them a unifying iconographic element that represented the spread of pan-Andean religious beliefs. The autonomy of the various regional political entities was probably little affected by these movements. Generally, this

pattern may be compared with the rapid and widespread expansion in the Old World of such dominant religions as Christianity and Buddhism, each of which carried its own ideology and related iconography across national and physical borders.

Quite different is the nature of artistic expansion typified in the Inca state of the late fifteenth and early sixteenth centuries A.D. The Incas constructed through military expansion an empire that embraced the entire Andean area, with frontiers far beyond Peru itself. This expansion resulted in political occupation that affected most aspects of the society in the subjugated areas. Within this imperial context Inca art and architecture appeared in various forms and to differing degrees throughout Andean art of the period. Although an aspect of this influence was undoubtedly religious, Inca ideological beliefs being diffused with the state itself, its motivating force was political, and associated artistic diffusion must be regarded as a function of imperial conquest rather than the advancement of a great religion. Early examples of this type of expansion, albeit on a much smaller scale, are presented by the Moche and Chimú states of the northern coastal region; in both cases the main art style was diffused as a byproduct of political dominance.

Thus, Peruvian art has cultural meaning transcending aesthetic and technical mastery. The objects in the current exhibit should not be regarded solely as a collection of exquisite art works; they are also visual reflections from a long and intricate episode of human civilization. As such, they illustrate, in its Peruvian manifestation, the complex of religious beliefs, fluctuating political fortunes, and evolving aesthetic tastes that constitutes a large part of the cultural experience that can be perceived through the archaeological record of extinct societies.

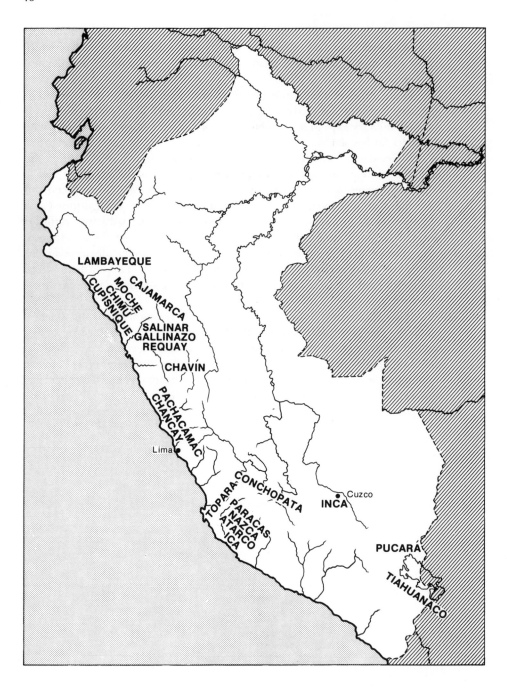

Map of Peru with the
archaeological cultures.

The Styles

All of the art styles described in this catalogue are represented in the accompanying exhibit. Although there are numerous styles that are not displayed, in general these are at present little known or understood and are awaiting further archaeological and art historical research. All of the major regional and interregional styles presently recognized in pre-Columbian studies of Peru are reflected in the Peabody Museum collections. They were derived from more than a century of research and encompass the entire spectrum of Peruvian art from the consolidation of civilization to the Spanish conquest.

Generally, the exhibited styles fall conveniently into highland and lowland categories, with coastal examples being dominated by artistic expressions of broad religious and political movements, the most important of which originated in the central and southern highlands. Where the archaeological record has produced a sufficiently comprehensive record, it is clear that there was a strong element of regional continuity through time, whether through the Cupisnique-Salinar-Gallinazo-Moche-Chimú continuum of the north coast or the Paracas-Nazca-Ica tradition of the south coast. The fact that some styles (i.e., Cajamarca, Requay, and Chancay) seem not to relate in this way is probably the result of insufficient archaeological knowledge rather than actual lack of chronological or spatial connections, although the strong tendency toward local specificity of style must always be recognized in a Peruvian art survey. It is significant in this case, however, that two of these "unrelated" styles, Cajamarca and Requay, derive from the northern highlands, areas that are among the least studied or understood to date. The better-known highland styles — Chavín, Tiahuanaco, and Inca — all have widespread occurrence. It is no accident that the two latter styles are indigenous to the southern Peruvian Andes, where highland-coastal physical and cultural connections were close throughout pre-Columbian history, thus facilitating all aspects of diffusion including that of art.

The Chavinoid Styles and the First Pan-Andean Religious Movement

Chavín de Huantar

Until recently it was accepted that the earliest of the great Peruvian art styles originated in the central highlands at a large religious site called Chavín de Huantar in the early first millennium B.C. The site itself consists of an elaborate stone-built temple containing platforms, terraces, and an intricate complex of subterranean passages and galleries. A considerable residential occupation ulti-

The Raimondi Stone from Chavín de Huantar.

mately surrounded the temple. The temple was embellished, inside and out, with large quantities of relief carving and a minor component of three-dimensional sculpture. Most of the motifs appearing in this sculpture clearly represent mythical anthropomorphized beings and stylized animals. The style of execution emphasizes linearity with the various subjects being rendered in an extremely abstract manner.

Motifs used at Chavín de Huantar appear throughout the Peruvian artistic tradition. Several large-scale reliefs eloquently illustrate this point. Among these important works is a large and famous stone plaque carved in low relief and probably originally attached to a wall. This relief, known as the Raimondi Stone, bears the image of a figure, which in various guises represents one of the most frequently portrayed and prominent of identifiable Peruvian pre-Columbian deities. This being, termed the "Staff God," appears on the Raimondi Stone as an erect, anthropomorphized feline, facing frontward, with a large rectangular head and outstretched arms grasping elaborate staffs in each hand. The mouth exhibits curved fangs; the toes and fingers are clawed. The hair is portrayed in the form of writhing serpents, which also project from the belt. An intricate pattern of superimposed feline faces surrounded by alternating rays and serpents emanates from the headdress. The lower ends of the staffs terminate in stylized feline heads.

Other examples of stone carving at Chavín de Huantar include rectangular slabs bearing abstract linear renderings of felines, eagles, serpents, and idealized humans, and large three-dimensional heads used as architectural decoration on the exterior wall of the temple, to which they were attached by tenons. These heads are vaguely human but incorporate well-defined feline features. In total this rich body of stone sculpture — probably the finest single inventory produced in pre-Columbian Peru — suggests that the stone temple of Chavín de Huantar marked the focus of a religious cult in which the feline element played a dominant role.

We have dwelt at some length on the specific nature of iconography and style at the site of Chavín de Huantar because they exhibit features that are characteristic of Peruvian art throughout its course and that appear at numerous sites across the whole Andean area. Thus, the feline motif is seen widely in all aspects of art, as are such figures as the stylized bird (used at Chavín de Huantar in repetitive bands to flank an elaborate gateway) and, most important of all, the Staff God. Such general motifs and stylistic traits serve to infuse the diverse regional art styles of Peru with an aura of overall unity, which varies in its deeper significance through time, sometimes reflecting close cultural ties through religious and political association, at others more superficial links innate within the context of a great civilization.

We mentioned at the outset of this section that it was long believed by students of Peruvian archaeology that the art of Chavín de Huantar represented

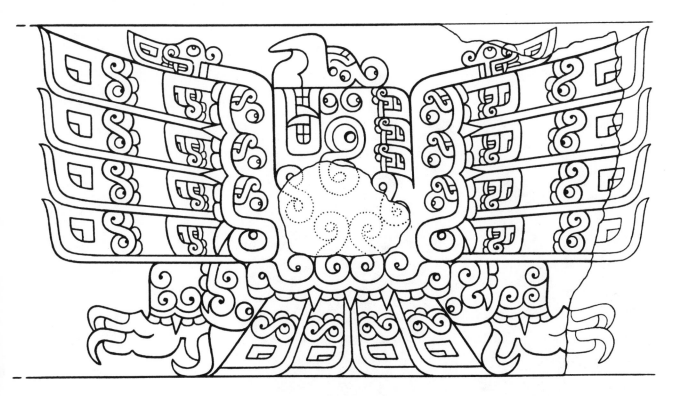

Carved cornice, Chavín de Huantar, depicting a condor or eagle with feline attributes.

the earliest manifestation of Andean art as a "Great Style," on a level with the established styles of other early civilizations. Furthermore, the overwhelmingly religious aspect of the Chavín art and architecture and the existence of related Chavinoid styles and temples elsewhere in Peru suggested that an important religious phenomenon had developed at Chavín de Huantar about 800 B.C., subsequently spreading to most of Peru during the succeeding 500 years, with the various regional art styles reflecting the religious influence of the original highland center. Recent archaeological work has, however, altered this view. It now appears that Chavinoid styles indigenous to the central and northern coastal regions in fact flourished in the late second millennium B.C., several centuries prior to the emergence of the mature Chavín style. Thus, it is no longer possible to regard Chavín de Huantar as the religious and artistic progenitor of Peruvian art. Instead, it seems much more likely that the site emerged as a strong highland religious center around 1000 B.C., integrating ideological influences from the coast on one hand and from the equatorial forest on the other into the tradition of village-based ceremonial centers, which had long formed the religious foci of the central highlands. The resulting influential cult must be regarded as only one in a

Cupisnique stone mace head.

series of closely related religious expressions that first emerged along the Peruvian north coast around 1500 B.C., gradually diffused to the highlands after 1200 B.C., and ultimately spread southward through the highlands to the south coast about 500 B.C. The significance of Chavín de Huantar, then, is not that it represents the earliest ceremonial center in the Andean area but that in its religious sophistication it was probably the most influential highland focus for the first great wave of ideological diffusion to sweep across Peru during the first half of the first millennium B.C. We shall see that in its complex art forms Chavín de Huantar provides an admirable starting point for a description of the diverse regional styles and their related cultures.

The Coastal Chavinoid Styles: Cupisnique and Paracas

A number of regional art styles reflect the earliest pan-Andean religious diffusion along the Peruvian coastal desert. Two of the best known of these Chavinoid styles are represented in the exhibit: Cupisnique of the north coast and Paracas of the south coast. They developed during the first millennium B.C., were generally contemporary with the art of Chavín de Huantar, with which they share important features, and flourished during a time of major social and technological transformation. The foundation of this change lay in the introduction of irrigation agriculture. Hydraulic systems followed a pattern that is still in use, with large canals tapping the rivers at their points of emergence from the mountain foothills and from there carrying water around the valley flanks to small canals to feed the fields.

The rise of irrigation agriculture had major effects on the life patterns of the coastal populations. The earliest irrigation systems were confined to the vicinities of the foothills where the coastal plain was most accessible to short simple canals. This location, often more than thirty kilometers inland, resulted in demographic changes; populations now lived in small villages near their fields away from the earlier shoreline settlements. Moreover, the new subsistence pattern required a well-organized labor force to build and maintain the canals and fields and a managerial class to organize such endeavors. Consequently, there evolved a trend toward labor specialization and social separation, with the individuals directing this increasingly structured society forming an elite ruling class at the apex of a gradually expanding pyramid of artisans, religious specialists, and food producers.

Another important development parallels the emergence of agriculture. This was the beginning of political structure. Each coastal valley constituted a discrete ecological entity. With the innovation of irrigation agriculture, each valley likewise became a potential hydraulic entity. The community that was strategically located so as to control the main canal outlets at the head of the river plain

possessed the ability to direct the water flow and, therefore, to dominate the agricultural production and general livelihood of all communities farther downstream. Consequently, in a short time most valleys were unified under a single dominant ceremonial center, such as the Huaca de los Reyes in the Moche Valley. The entire valley now constituted a polity, the ruling class of which incorporated wide territorial authority as well as local managerial functions.

The Chavinoid art styles were expressions of the ideological aspect of these developments. Both coastal valleys and highland basins contain large religious centers constructed during this period. Most of the coastal centers predate the chief highland sites. All are generally similar in form and in their sculptural association with such religious motifs as the feline and the anthropomorphic human figure.

It appears that during the period characterized by the Chavinoid styles and their immediate antecedents there emerged a sociotechnological pattern basic to Peruvian pre-Columbian civilization. People were brought into larger, more effectively organized social units, which were governed by elite classes who exerted their authority from large ceremonial centers such as the Huaca de los Reyes and Chavín de Huantar. The ruling elite may well have been religious practitioners themselves; in any case, they clearly made use of the rich religious iconography of the Chavinoid styles to enhance their authority and to maintain control over expanding populations and territories. The Chavinoid styles formed components of a loosely connected pan-Andean religious phenomenon that may be regarded as the ideological catalyst to Peruvian civilization at this important stage of its evolution.

Cupisnique

The best-known northern coastal style of the so-called Chavinoid horizon is the Cupisnique, named after the valley where it was first discovered by the great Peruvian archaeologist Rafael Larco Hoyle. The Cupisnique style had its origins in a much earlier coastal culture and may be a late manifestation of an ideological complex that, appearing on the coast several centuries earlier, was one of the formative influences on the Chavinoid artistic-religious florescence.

Cupisnique art is known primarily through its distinctive ceramics. Ceramic vessels were usually fired in a controlled, oxygen-reduced atmosphere. This procedure gave Cupisnique pottery its characteristic gray and black surface color. A minor class of oxygen-fired wares was also produced. Vessel forms include one that is recognized as the most characteristic ceramic indicator of northern coastal ceramic art, the stirrup-spout jar. This form, with a globular or modeled body, is topped by a rounded stirrup surmounted by a short vertical spout. In the earliest examples, the vessel bodies were shaped by hand. Later, they were almost always moldmade, with two identical sections joined together prior to firing. Stirrups and

Cupisnique flask.

spouts were shaped by first rolling wet clay over pieces of cane and then attaching the resulting stirrup to the moldmade bodies. The entire vessel was then fired, and the cane formers were burned away during the process. Other common Cupisnique forms are tall bottles with straight spouts and a variety of bowls and plates, most of which are also associated with the ceramic art of Chavín.

Dominant decorative canons are those already seen in the sculpture of Chavín de Huantar. A strong linear element prevails, with incised themes often depicting the abstract feline and serpentine motifs common at the highland site. In addition, modeling, a feature more easily applied to ceramic than stone art, was introduced into northern coastal art at this time and persisted throughout the region's artistic tradition. Modeled vessel forms range through a wide variety of human, anthropomorphic animal, and vegetal subjects, all of which subsequently recur as typical themes in the art of the region.

In addition to its ceramic art, the Cupisnique style in common with the other Chavinoid styles incorporated a highly accomplished metalworking technology and produced splendidly decorated textiles. Textile manufacture possesses a larger history in Peru than any other artistic or technical form, predating ceramic and metal technologies and dating back to the preagricultural settlements of the Pacific littoral in the third millennium B.C. Metalworking first appeared in the southern highlands about 1500 B.C., and by 800 B.C. artisans of the Chavinoid cultures, including Cupisnique and Chavín de Huantar, were working gold. Apparently, finished items were used most often in elite and religious locations, and they have usually been recovered from the burials of persons of high social or religious standing. Most of the Chavinoid goldwork was formed from thin hammered sheets, which were decorated by repoussé or embossing and then soldered together into the desired shape. Minor art forms included jewelry-making from semiprecious stones, gourd decoration, and shell engraving.

Paracas

The second of the coastal Chavinoid styles included in the current exhibit is the Paracas style from the Ica, Nazca, and Acarí valleys of the southern coastal region. Paracas art, chiefly known through the medium of pottery, has been the subject of intensive stylistic analysis by scholars from the University of California at Berkeley and is entirely derived from excavated burials. The style displays a developmental sequence commencing at a period roughly around 600 B.C. and ultimately evolving into the Nazca style about 300 B.C.

Paracas ceramics, while exhibiting strong Chavinoid elements, retain a distinctive local strain, which is clearly illustrated in both vessel forms and decoration. The style is characterized by Chavinoid stirrup-spout jars and bowls and vessels of local derivation including the typical double-spout and bridge forms and similar shapes in which one spout is replaced by an animal or bird figure.

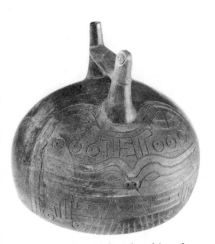

Paracas vessel incised with a feline face.

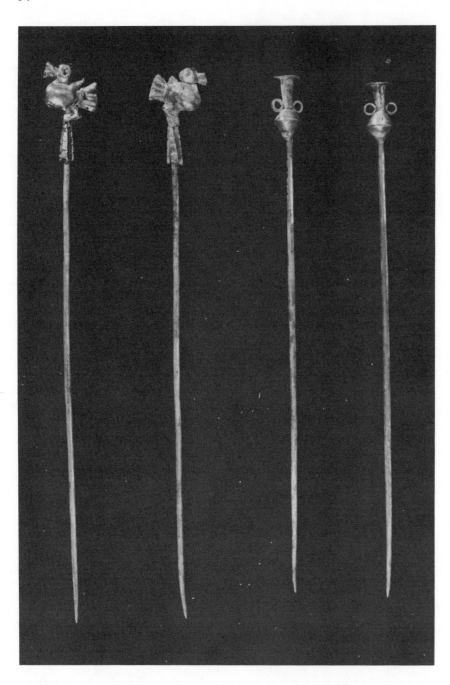

Silver pins with decorated heads, north co

Decoration is largely dominated by linear incision with abstract anthropomorphic design, in which the Chavinoid feline is prominent, painted in zones of contrasting color. Thus, Paracas art embodies the two basic qualities of pre-Columbian Peruvian artistic inspiration: local tradition overlain by and merged with externally derived influences. In the Paracas case, research has demonstrated that its stylistic evolution closely parallels that of Chavín de Huantar, suggesting that areas far distant from each other maintained close contact throughout the later first millennium B.C. Contact may have been facilitated by exchange or vertical subsistence networks, which, as we have stressed, were especially strong between the southern highlands and coast. Although it is difficult to determine the nature of the relationship, the Chavín de Huantar-Paracas parallels offer an intriguing glimpse of the long-distance cultural networks that existed in Peru throughout its history.

Stylistic Continuity in the Northern Coastal Region

Following the Chavinoid interregional relationships of the first millennium B.C., the regional traditions of Peru separate. From this period down to the Inca expansion of the fifteenth century A.D., the styles of northern Peru, especially those of the coastal region, develop in a manner that differs markedly from those of the southern regions both in iconographic content and technical concept. In comparison with the continuing close relationship between the art of the central and southern highlands and the adjacent coastal regions, stylistic contact between the northern highlands and coast was minimal. This stylistic pattern reflects the broader cultural configurations of the period between 300 B.C. and A.D. 1450, dates that span a long period of social and political evolution. This process of evolution, although not always smooth, moved steadily toward the formation of larger political units and the accompanying elaboration of governmental structure in which monopoly of authority by purely religious institutions gave way to a multifaceted power complex under the centralized control of a divine monarch. A parallel development was the emergence of a full urban pattern, which culminated in the establishment of great cities, precisely planned to function as the foci of a peculiarly Andean sociopolitical order.

During the initiation of this evolutionary process in the Cupisnique period, the northern coastal valleys were unified internally under the authority of large ceremonial centers in which the prominence of the various Chavinoid religious styles eminently demonstrated their dominant ideological affiliation. These centers possessed only small residential areas, the living quarters of an elite group of religious practitioners and their retainers. The bulk of the population lived in small villages scattered throughout the valleys, exploiting the now-refined agricultural

irrigation systems. Soon, however, a tendency toward intensification of settlement was in evidence with small loosely planned towns such as Cerro Arena in the Moche Valley occupying some two square kilometers. This pattern toward intensive settlement was to characterize northern coastal human occupation throughout its pre-Columbian history, although it was to be expressed in varying ways.

Shortly after A.D. 300, the traditional pattern of localized valley polities changed with the emergence of the first multivalley political state. The Moche state, centered at the site of the vast pyramids, the Huaca del Sol and the Huaca de la Luna, expanded from the Moche Valley to encompass most of the north coast. Local administration within the state followed the existing pattern, with large ceremonial centers embellished with religious iconography dominating each component valley. After A.D. 600, the state entered a period of decline and contraction, losing its southern territories. Reorganization during this period involved the abandonment of the old system of rural villages dominated by religiously oriented ceremonial centers. Instead, densely populated and well-planned cities emerged, containing new components of primarily secular function such as administrative structures, corporate storage facilities, and palaces. The long-lasting religious paramountcy was now merged into a new and complex system ruled by a king. This new system was temporarily interrupted in the south with the final collapse of the Moche state around A.D. 750. It probably continued in the north in a smaller state centered in the Lambayeque Valley. Local legends of the area related to the Spanish tell of a strong Lambayeque dynasty at this time, which was ultimately conquered by the Chimú empire.

The rise of the Chimú empire after A.D. 1000, with its capital at Chan Chan in the Moche Valley, again involved the incorporation of the entire north coast and much of the central coast into a militaristic state, which was allied with a neighboring state centered at Cajamarca in the adjoining highlands. The Chimú empire was ruled by a succession of divine kings and produced the largest cities yet seen in Peru. The cities, however, unlike their late Moche predecessors, were vast, specialized administrative centers in which the extensive imperial family, aristocracy, bureaucracy, and their supporters lived and ruled the empire. The subject populace continued to live in small rural settlements and to operate the great agricultural systems that were now made possible by the construction of huge intervalley canals. The Chimú state flourished from about A.D. 1200 to 1465, when it was swallowed up by the greater imperial Inca phenomenon.

The art styles of the northern coastal region between 300 B.C. and A.D 1400 represent a strong artistic tradition that emerged from the Chavinoid styles and their immediate predecessors. Art techniques and decorative modes that coalesced into the formal aesthetic patterns seen in the Cupisnique and related styles were to persist in the art of northern coastal Peru throughout its development. Although strong modifying influences arose intermittently with the fluctuation of political

Salinar stirrup-spout vessel in the form of a building.

Gallinazo double-chambered vessel decorated in the negative painting technique.

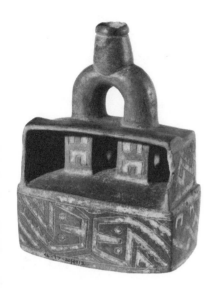

and social institutions, they were invariably incorporated into the tradition, causing little basic change. Several of these northern regional styles are represented in the collections of the Peabody Museum and are displayed in the current exhibit. Of these, the Salinar and Gallinazo styles are distributed in the southern part of the region and the Lambayeque in the north, while the Moche and Chimú encompass the entire north coast.

Salinar

The Salinar style is, like most Peruvian styles, chiefly defined by its ceramic traits. Salinar, first identified from cemetery excavations in the Chicama Valley by Rafael Larco Hoyle, shares important features of Cupisnique pottery and must be regarded as a close successor of the Chavinoid artistic phenomenon. Two important decorative techniques typify Salinar ceramics. The first — frequent use of incised decoration — places Salinar squarely in the Chavinoid tradition. The second is an innovation in this tradition. Vessels are often decorated with a white design painted on an underlying red base. Designs are most frequently linear and geometric with various configurations of triangles, stepped lines, and zigzag bands most prominent. This white-on-red painting technique had parallels elsewhere in late first millennium B.C. Peru and may well have reflected a popular and widespread decorative trait.

The forms of Salinar vessels also stand solidly within the developing northern coastal tradition. The stirrup-spout shape first seen in Cupisnique pottery is popular. Vessel bodies exhibit one of the most characteristic artistic concepts of the region — plastic treatment of ceramic surfaces. This custom, already seen in Cupisnique art, proliferates in Salinar and succeeding styles, resulting in a wide variety of sculptural forms that reflect many aspects of human experience. Thus, residential and ceremonial buildings, human and animal life, and mythical beings are all boldly depicted in the three-dimensional medium of pottery. Technical traits include an increase in use of the oxidizing firing technique and the resulting production of red-surfaced pottery and the now common utilization of molds in the creation of modeled forms.

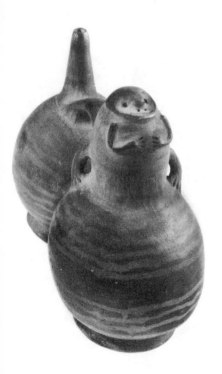

Gallinazo

The Gallinazo style succeeded the Salinar on the north coast during the initial centuries of the first millennium A.D., in all probability evolving from the earlier style. The Gallinazo style is named after a large archaeological settlement of the same name in the Virú Valley investigated by Wendell Bennett in 1938; its chronological relationship with the other regional styles was later determined by William Duncan Strong and the Peruvian Rafael Larco Hoyle in the 1950s. The forms and decorative canons of Gallinazo art closely resemble those of the Salinar style. Redware vessels dominate the Gallinazo ceramic inventory. Although there

is a continuing emphasis on natural representation, portrayals of stylized feline forms suggest the persistence of the religious cult first expressed by the Chavinoid styles. Common features are the use of molds to create modeled forms, incision, and geometric decoration. Important among a variety of forms are the stirrup-spout vessel and double-chambered forms, in which two spouts and a flat bridge surmount the vessel bodies.

A specific decorative trait, which has come to typify Gallinazo ceramic art, possibly marks a rare feature of artistic influence from the highlands. Many Gallinazo vessels are painted with a distinctive black-banded "negative" technique. Negative painting involves first painting the desired design onto the vessel with a resist material such as wax or clay. The vessel is then either smoke-darkened or dipped into black wash, the color being kept away from the design surface by the resist material. When the wax or clay is removed, the pattern stands out in the original color against a black background. There has been much speculation about the origin of this complex technique because there is no local antecedent. The existence of both the technique itself and its dominant curvilineal designs in the Requay style (discussed later in this catalogue) of the adjacent highlands indicates that they originated there and were adopted by the Gallinazo artists and incorporated into their technical repertoire.

Moche

The Moche style, the style of the Moche state, which dominated the entire northern coastal region from between A.D. 200 and 750, in many ways can be regarded as the culmination of almost two thousand years of artistic evolution in the region. Its early roots clearly lay in the technical, aesthetic, and symbolic concepts that first coalesced in Cupisnique art and were enriched by the succeeding Salinar and Gallinazo styles. However, this artistic heritage was exquisitely blended with creative innovation to produce a style that in its versatility and refinement ranks among the world's great aesthetic expressions.

The most outstanding surviving component of Moche art is the pottery. This medium demonstrates to the fullest extent that Moche potters commanded a spectacular range of technical skill and aesthetic expression, all executed within very structured formal and ideological limits. Basic vessel forms, for instance, are few in number. Oxidized redware stirrup-spout vessels, which had been popular earlier, provided the formal medium for the majority of Moche art works, although numerous reduce-fired blackware vessels were also produced. The decoration shows mastery of two complementary techniques — modeling, used to portray a broad range of human and animal life, and painting, which emphasizes the three-dimensionality of the work. These techniques, applied in combination, produce an art form that attains the most exquisite naturalism and depicts many aspects of human life on the Peruvian north coast during the Moche period.

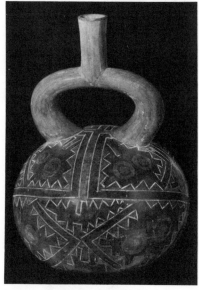

Moche stirrup-spout vessel.

Portrayals of humans often appear to be portrait busts in pottery, so precisely are individual physical features represented, while portrayals of animal life exhibit a consummate sensitivity of form and expression, which undoubtedly reflects the close relationship of Moche artists and their natural environment.

There is, however, a very different aspect to Moche art. Line painting in brown on a cream base also constitutes an important component of the style. While some scenes executed in this manner are depicted naturalistically, most are stylized and range from purely abstract decorative motifs, in which the geometric patterns of earlier Salinar and Gallinazo art are further refined, to stylized representations of mythical beings and ritualized activities. It is from this fine-line painting style that scholars obtain a glimpse of Moche religious practices and beliefs.

It appears that a well-defined group of important religious themes are portrayed in Moche fine-line painting. Christopher Donnan of the University of California, Los Angeles, has analyzed this art and has defined various themes. Foremost of these is the so-called Presentation Theme, in which a supreme deity, dressed in elaborate costume with rayed headdress and serpent belt, is the focus of a variety of ritual activities including an offertory procession. Other participants in the scene include human, animal, and anthropomorphic beings. Many of the mythical beings constantly portrayed in Moche art are brought together in the Presentation Theme, with their functions being well defined. The many examples of this scene strictly maintain the qualities of functional definition and compositional integrity. Such structured iconographic themes may be regarded as having conveyed clear religious meaning to the Moche people, just as religious art of other times and places has utilized imagery and myth to convey its message. It has been suggested that the deity with the rayed headdress and serpent-belted costume is in fact the same being as the Staff God from the Raimondi Stone at Chavín de Huantar because the identical accoutrements denote this link. If this is so, Moche religion here incorporates at the same time great continuity of ideological belief through the intervening thousand years and also drastic reinterpretation, the supporting Moche pantheon showing little resemblance to subsidiary deities from the sculpture of Chavín de Huantar. Instead, supernatural beings with coastal identification are common; sea creatures and coastal animals such as fox and deer frequently appear.

Religious themes also possess shamanistic and healing connotations. Individuals are sometimes portrayed with what appear to be healing paraphernalia similar to those still used on the Peruvian north coast by *curanderos* or folk healers. Thus, various cacti, fruits, and animals are imbued with magical power and are used in ritual healing ceremonies. It is clear that a large component of Moche art also deals with such activity. Thus, Moche art served as a vehicle for pure aesthetic expression, but it also conveyed well-defined ideological messages involving a

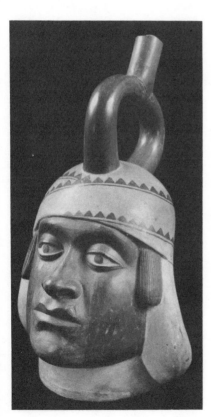

Moche portrait vessel.

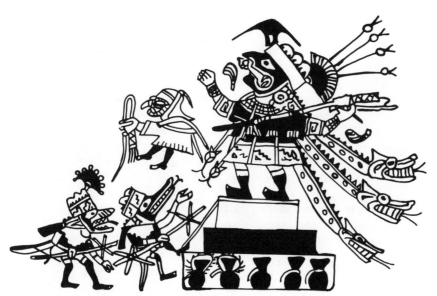

Fine-line scene from a Moche vessel depicting anthropomorphic deities.

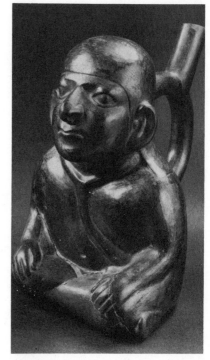

Moche figurine in the form of a squatting man.

complex religious pantheon whose member deities were equated in form and personality with the characteristic natural life of the coastal desert valleys.

A final aspect of Moche ceramic art is its stylistic evolution. The stirrup-spout vessel changes shape through time, becoming generally larger and taller, with the stirrup increasing in size in proportion to the vessel body. Related stylistic evolution sees the early trend toward large-scale naturalistic modeling vanishing in the ultimate developmental phase to be replaced by intricate and abstract fine-line drawing on flat vessel body surfaces. This evolutionary change coincided with the drastic political disruptions that affected the Moche state in its declining period and resulted in the loss of its southern territories and the eclipse of the traditional religious paramountcy of the ceremonial centers. The change in art may well have reflected these developments and implied rejection of the religious beliefs and related naturalistic iconography, which had proven inadequate to meet the needs of the state at this time of crisis.

Although Moche art and its related religious beliefs are best known through pottery, other important media were also used. Buildings were decorated with mural painting. Gold, silver, copper, and various alloys were worked; and wood, bone, shell, and textile art also flourished. However, these forms are less well preserved than ceramic art, which appears to have been the preferred art form.

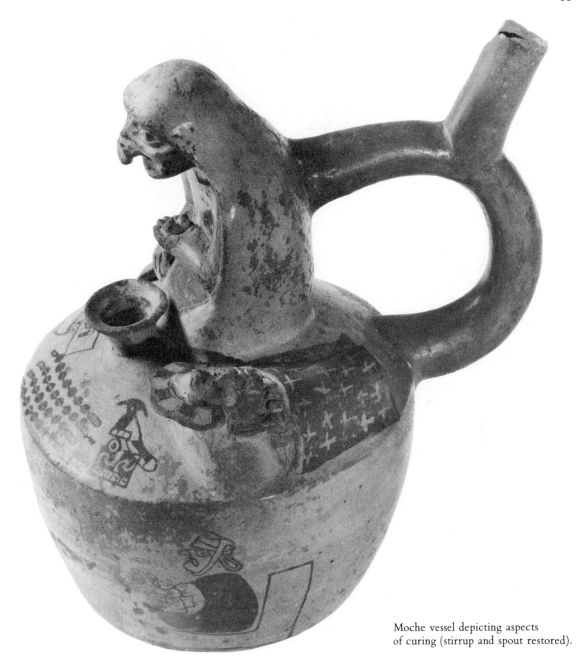

Moche vessel depicting aspects
of curing (stirrup and spout restored).

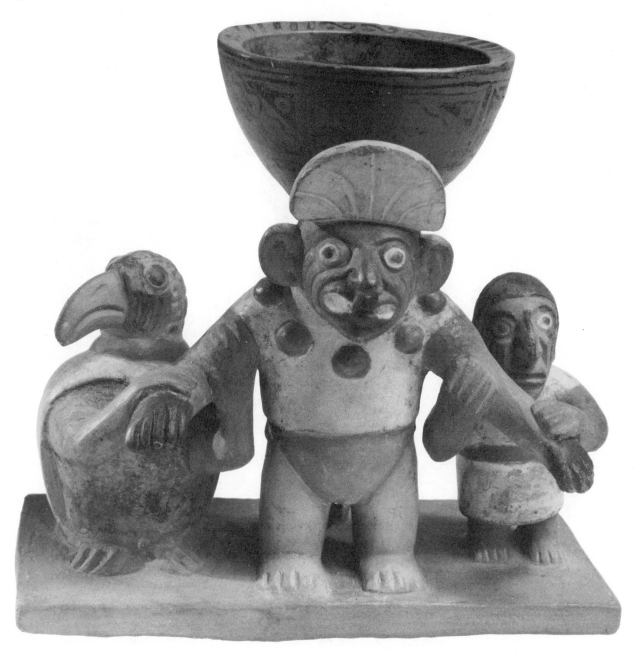

Moche figurine with religious connotations.

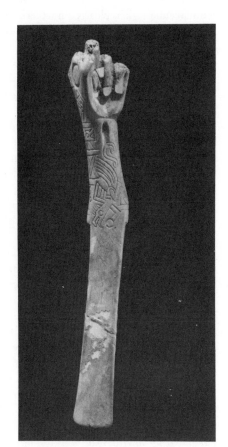

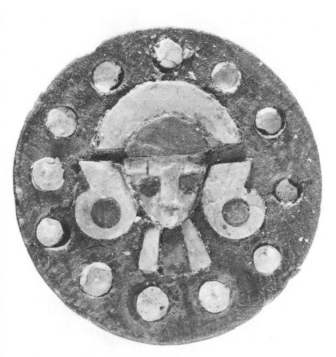

Moche earspool. Wood with shell inlay.

Carved wooden post and bone spatula carved in the form of a hand in the half-fist position. Moche period.

The Chimú and Lambayeque Styles

The last northern coastal style prior to the Inca conquest of the region was the Chimú style. The art of the Chimú empire owed much to its direct ancestor, the Moche style, sharing a propensity toward naturalistic representation and its characteristic forms. However, there was a gap of roughly 200 years between the disappearance of the Moche state and its related style and the rise of the Chimú culture. In the southern part of the region, the geographical heart of both Moche and Chimú art styles, these years are poorly recorded and understood both politically and artistically. However, in the northern part of the region the art style relating to the Lambayeque dynasty, which preceded and was conquered by the Chimú, provides a link between the two better-known expressions. The Lambayeque style is clearly a northern coastal regional art form closely related to the earlier styles. The naturalistic molding technique and sensitive treatment of human and animal life in Moche art is maintained in the Lambayeque style together with many of the characteristic vessel forms. However, local influence is also evidenced in a group of distinctly spouted forms, in the resurgence of double-chambered forms rarely seen since the Gallinazo style 500 years previously, in a preference for reduce-fired blackware, and in the subordination of linear painting from its dominant Moche role to a minor decorative adjunct. Thus, the Lambayeque style incorporates the two basic qualities of Peruvian art and culture by expressing a widespread regional artistic tradition in a distinctly local form. However, on a wider level the style was the vehicle by which this tradition passed from the declining Moche phase to the dominant artistic form of much of coastal Peru in the art of the Chimú empire.

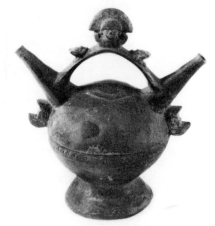

Lambayeque double-spout and bridge vessel.

Chimú art, expressed in a variety of media, owes much of its inspiration to the earlier Moche artists but at the same time shares some of the innovative traits of the intervening Lambayeque artists. Many ceramic forms are pure Moche in derivation, the stirrup-spout vessel again being abundant. Likewise, the lifelike modeling, long a prominent ingredient of the northern coastal artistic heritage, maintains its popularity. However, the common use of double-chambered vessels, the preference for blackware, and the general absence of painted decoration marks the impact of the Lambayeque local style on the northern regional tradition, while the adoption of press molding probably reflects influence from the south during the inadequately understood period immediately following the collapse of the Moche state.

In its thematic content, Chimú ceramic art exhibits abbreviated ideological composition, the complex religious iconography of Moche art largely being abandoned. Although some examples do exist of Moche-like mythical beings participating in ritualistic activity, most Chimú iconography is confined to portrayals of naturalistic themes or of individuals of high secular status. This change may relate to a trend away from the earlier theocratically dominated society

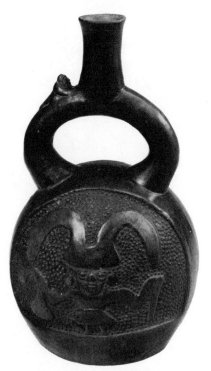

Chimú stirrup-spout vessel.

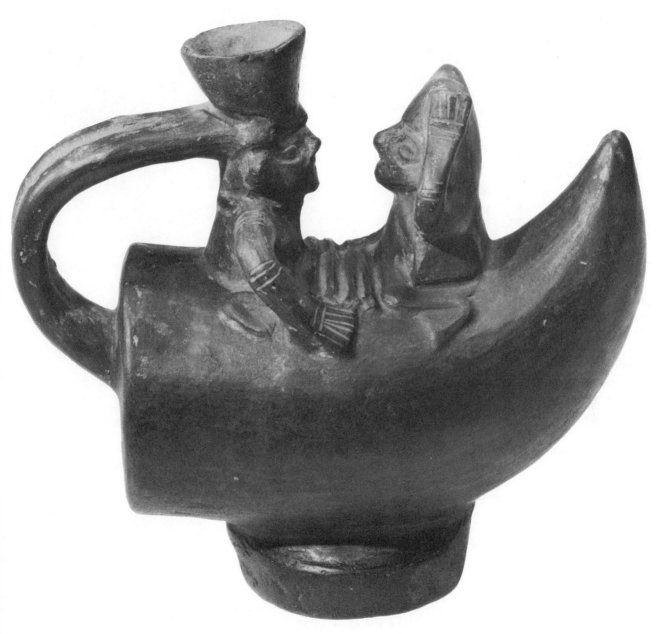

Chimú vessel depicting a reed fishing raft (see p. 10).

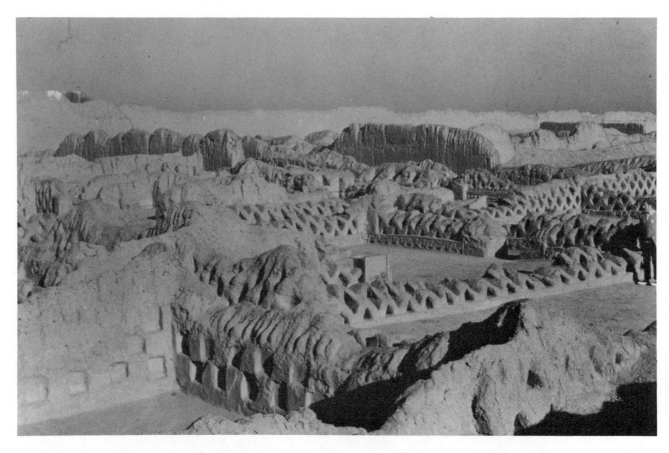

toward one in which an expansionist state bases its power more on military strength and elite status than on religious authority. In such a state, religious art can be expected to play a secondary role to secularized state art.

Accompanying this change in thematic emphasis is a decline in artistic quality. Modeled forms are less carefully finished, and the clear definition of line and shape that epitomizes Moche art is absent in the Chimú style. In fact, Chimú art when viewed in relation to Moche art presents the appearance of having been mass produced by state artisans, with repetition and high quantity of production taking precedence over quality. Again, this tendency would conform to the functional movement from religious craft to an imperial art style. A tendency toward repetition and loss of quality certainly epitomizes the art of other early expansionist states, such as imperial Rome and New Kingdom Egypt, and probably explains the Chimú case as well.

Ciudadela Tschudi at Chan Chan showing the decorative treatment of plastered walls.

Chimú artists were also active in other media. Again, an overweening aura of high secular status and wealth permeates this work. Vast quantities of gold and silver were worked, much of this intended to embellish such status objects as thrones, the litters of nobles, headdresses, and jewelry. Featherwork and textile manufacture were also performed, the latter like ceramic art displaying a repetitive quality that strongly contrasts with the individualized decorative fabrics of other styles. Wooden implements such as ceremonial maces and staffs were also produced, the woodcarvers exhibiting a mastery of intricate abstract decoration, which is mirrored in the latticelike mud-brick architectural embellishment seen at Chan Chan, the capital of the Chimú state.

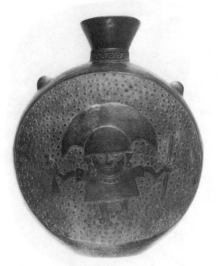

Chimú vessel.

Chimú silver *Spondylus* shell.

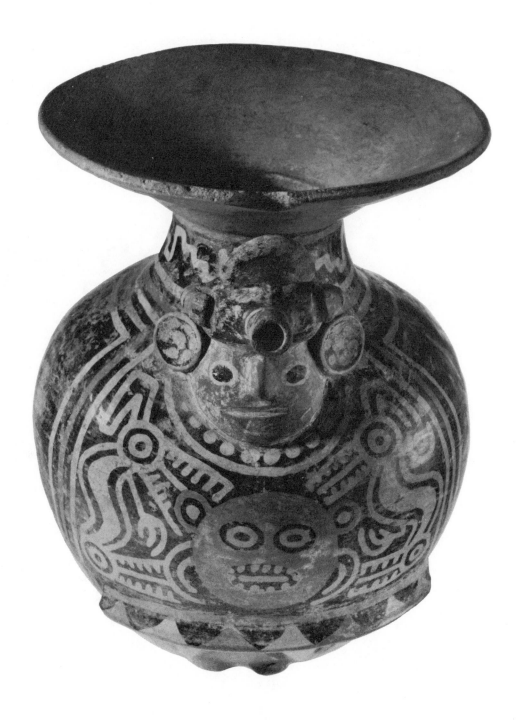

Highland-Coastal Interaction in the North: Requay and Cajamarca Styles

We have noted that in general there was little substantive stylistic interaction between the traditions of the northern coastal region and the northern highlands. However, minor influences were undoubtedly transmitted within the framework of the exchange networks that functioned continuously, enabling highlanders to obtain necessary subsistence commodities from the more fertile coastal lowlands and the coastal dwellers to obtain such items as tropical bird feathers (a status item) from the equatorial forest and llama from the Altiplano. These minor stylistic influences are most prominently seen in the relationships of the coastal styles with two styles of the adjacent highland — Requay to the south and Cajamarca to the north.

Requay

The most obvious instance of stylistic interaction between the north coast and the highlands has already been mentioned, occurring between the Gallinazo style of the coast (ca. A.D. 0–300) and the Requay style which is found chiefly in the contiguous highlands (ca. A.D. 200–600). We have noted that the major trait shared by the two styles was the common use of the difficult negative painting technique (see p. 58). Such stylistic affinity denotes the existence of relatively intensive interaction between the highlands and the coast during the initial centuries of the first millennium A.D.

The Requay style takes its name from a modern town located on the highland course of the Santa River. The area usually considered the home of the Requay culture comprises the highland basin of the Santa, although Requay art also occurs to a lesser extent in the adjoining coastal valleys. There is no evidence that this stylistic distribution paralleled any political or cultural unification of highland and coast; it may more correctly be regarded as the result of regular exchange traffic through the region. The social and political organization of the people who created Requay art is as yet unknown, their only material residue being ceramic art almost entirely derived from burials, scattered settlement vestiges with houses constructed from large stone slabs, and a distinctive style of stone sculpture.

Requay ceramic art, by far the best-known aspect of the culture, exhibits an attractive, colorful style in which naturalistic modeling is balanced by abstract painted decoration. The negative painting technique, which is shared with Gallinazo art (see p. 58), is carried to its utmost refinement with three-color negative achieved by application of red to areas previously treated by smoking, the red and black designs being complemented by a flat white base. Subjects commonly portrayed include animals — mainly llama and felines — humans, and architectural structures. Painted decoration is overwhelmingly geometric in nature and

Requay vessel decorated in the three-color negative painting technique.

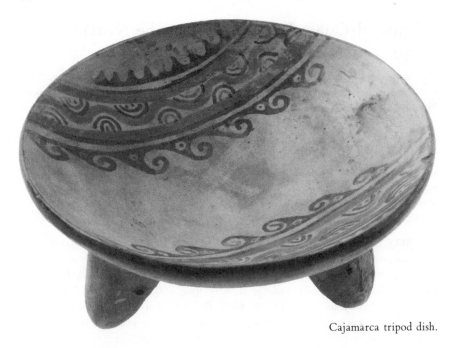

Cajamarca tripod dish.

includes purely abstract designs and stylized eagles, serpents, and felines. Serpent-like creatures and felines are most often depicted and probably carry religious meaning. It is significant that the main themes of Requay art maintain the religious emphasis placed on feline, eagle, and serpent forms first manifested formally in the highlands through the Chavinoid style of nearby Chavín de Huantar. The Requay style, appearing some 500 years later, is at least a partial outgrowth of the earlier style both in artistic and religious terms.

Cajamarca

The Cajamarca style is the artistic expression of a little-understood culture that flourished in the highlands north of Requay. Neither the culture area nor Caja-marca cultural origins are yet precisely known. The style is, however, known to have had a long developmental tradition extending at least from the early centu-ries A.D. until the Inca conquest. Cajamarca ceramic items were occasionally taken down to the coastal lowlands, where they have been found in Moche and Chimú contexts. Moreover, Cajamarca decorative style in rare instances appears on coastal works, denoting artistic influence. Thus, it is clear that the same type of informal interaction that characterized the Requay-Gallinazo highland-lowland relationship also took place farther north. In fact, toward the end of the pre-Columbian era this interaction seems to have been given more formal structure.

Ethnohistorical accounts tell of an alliance between the coastal Chimú empire and its highland neighbor, Cajamarca, to resist the expanding Inca threat. Both states were subsequently incorporated into the Inca Empire.

Cajamarca pottery, through which the style is known, is characterized by bowls and plates made of white kaolin paste, which serves as the foundation for red and black painted designs. Decorative motifs are curvilinear in nature, consisting of spirals, volutes, and feathery filler lines. Little or no representational art was produced, and cursive abstraction dominated the style. In general, the Cajamarca style is a refined expression in which linear painting enhances simple vessel shape to produce a well-balanced, elegant art form. Significantly, in contrast with the neighboring coastal styles, there is no iconographic evidence that Cajamarca ceramic art carried any religious meaning. Instead, its primary function appears to have been to serve purely aesthetic needs.

The Southern Peruvian Artistic Tradition

The evolutionary development of art styles in southern and much of central Peru differed markedly from that described for the north in the period between the Chavinoid religious diffusion and the imperial Inca expansion. Whereas the northern coastal and highland regions underwent essentially independent cultural developments with only minor significant interaction, the situation farther south can only be understood within a context of broad interregional contact. Geography tended to foster the different patterns, encouraging the formation of strong polities along the north coast, which was always able to resist any political incursion from the topographically divided highlands. By contrast, in the south, the large geographical units of the highlands promoted large-scale cultural unity with a resulting tendency for expansion to take place downward onto the adjacent coastal plain and its small, isolated valleys. This geopolitical pattern carried with it related implications for broad aspects of culture history, including artistic expression.

From the time of the Chavinoid expansion into the south in the latter half of the first millennium B.C., the art of south-central and southern Peru maintained broad stylistic unity. While it may be somewhat simplistic to speak of a southern style, a general artistic tradition undoubtedly emerged with related stylistic components owing much of their character to a common highland Chavinoid ancestor. These styles were characterized by broadly similar artistic canons, suggesting the existence in much of southern Peru of a common aesthetic context. Moreover, there occurred at least one major period of artistic development in which iconographic content clearly reflected general unity of religious belief as well as stylistic character, demonstrating that the sharing of stylistic traits was to some extent only the superficial aspect of deeper ideological affinity.

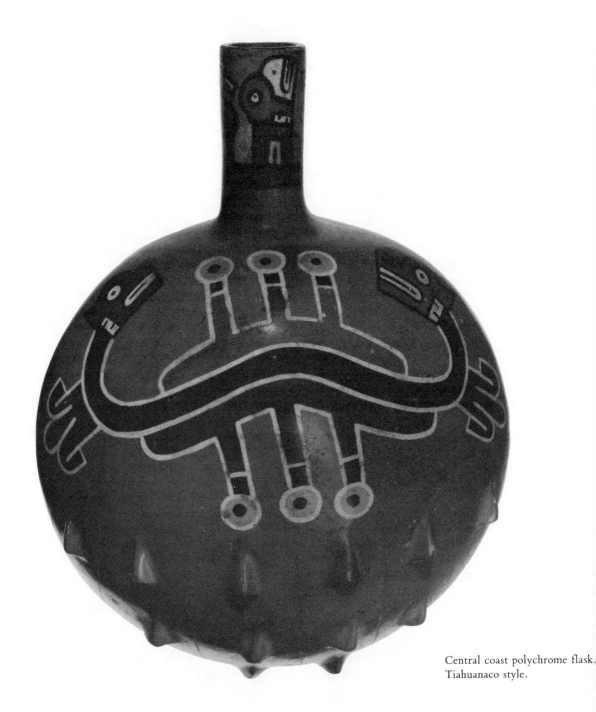

Central coast polychrome flask.
Tiahuanaco style.

The styles represented in the Peabody collections illustrate this southern cultural configuration. Although there has been controversy among scholars about this issue, it does seem probable that the earliest well-known styles of the southern highlands, of which the Pucará and Tiahuanaco examples of the late first millennium B.C. are included in the exhibit, derived important features from the style of Chavín de Huantar. The Pucará and Tiahuanaco styles also share prominent traits with the Chavinoid Paracas style of the south coast (see p. 55), most significantly the use of incision and zoned polychrome colors to portray bold large-scale designs in which single motifs dominate, unlike the complex narrative scenes of the north coast art. Modeling plays a secondary role in these styles, in contrast to its primary role in the north coast tradition. These basic traits characterize the southern Peruvian tradition throughout its pre-Incaic course, as does the widespread highland-coastal interaction evidenced first in the Pucará, Tiahuanaco, and Paracas styles and maintained in the long-lasting Nazca style of the coast and its highland counterparts.

In addition to the stylistic unity of southern Peru there was significant religious contact, also expressed through art. The single most important theme of the art of Tiahuanaco is a supreme deity, which in all its essential features replicates the Staff God of the Raimondi Stone from Chavín de Huantar and is very probably the same being. This deity appears not only in the art of the Titicaca Basin but after A.D. 700 in the art of the remainder of the southern and south-central highlands and also of the neighboring coast, illustrating a trend toward broad religious interaction at this time, which, however, left room for local interpretation. Styles represented in the present exhibit that reflect this influence include the Nazca of the south coast, the Pachacamac of the central coast, lesser-known examples from the central coast and highlands, as well as the focal Tiahuanaco style.

Following the period of Tiahuanacoid religious expansion, there appears to have occurred an interlude in which local styles became more dominant. Whether this development reflects a corresponding regionalism in other aspects of culture is at present unclear. Thus, the Ica and Chancay styles of the south and central coasts and their highland contemporaries possess less stylistic affinity than do most of their artistic predecessors. This regionalism was terminated first by the southward expansion of the Chimú state through the central coast and ultimately by incorporation of the entire Andean world into the Inca Empire.

Pucará and Tiahuanaco

The styles named after the Titicaca Basin sites of Pucará and Tiahuanaco were part of a widespread cultural tradition that extended from northern Bolivia to the coastal Ica Valley in the final centuries of the Chavinoid expansion and the immediately succeeding period (ca. 500 B.C.–A.D. 500). This tradition as

expressed in art incorporated the southern Chavinoid traits, already noted for the Paracas style and its progenitor at Chavín de Huantar. Such traits include zoned polychrome painting in which the zones are outlined by incised lines and prominence is given to the frontal feline face and portrayal of human heads. The emphasis at this time on bold polychrome design became, as we have already pointed out, the dominant decorative canon of southern Peruvian art.

The Pucará style of the northern Titicaca Basin derives from an important settlement of the same name. Pucará dates from the last centuries B.C. and flourished in the early first millennium A.D. The site consists of an impressive ceremonial structure, which is built of dressed stone blocks and associated stone sculpture embellished in low relief and is surrounded by many small buildings. Pucará was probably an important political and religious center with a significant residential population. Excavations at the site in the 1940s conducted by Alfred Kidder II, who was then associated with the Peabody Museum, produced the ceramic evidence through which the Pucará style is known. Polychrome incised designs on fancy pottery commonly depict frontal feline heads (some of which are modeled in relief), bold geometric decoration, avian heads, and serpents, all of which are integral components of the iconographic inventory of both the earlier southern Chavinoid styles and southern Peruvian art in general.

The Tiahuanaco style, derived from the great stone-built settlement on the Bolivian Altiplano near Lake Titicaca, has a long and influential history. The foundations of the Tiahuanaco style lie in the first millennium B.C.-Titicaca Basin tradition which also included the Pucará style. Indeed, the two styles are extremely similar in character, clearly demonstrating their common heritage. Also, like its Pucará counterpart the Tiahuanaco ceramic style is related to a great ceremonial settlement. Tiahuanaco was a key economic center, which dominated commodity exchange within a large region. The site was also an important center for metallurgy and probably produced the earliest Andean bronze. Associated field systems and irrigation construction indicate that a large population resided at the settlement. Moreover, the wide distribution of specifically Tiahuanacoid artifacts strongly suggests that by A.D. 500 the site was the center of political and economic power of a huge area of Bolivia, Chile, and extreme southern Peru.

Furthermore, there is an important religious aspect of the architecture of Tiahuanaco. The ceremonial structures at the center of the settlement include large stone-built compounds, platforms, and supporting structures. This principal architecture was accompanied by huge columnar sculptures resembling human figures, the sculptured details of which were executed in high relief. In addition, the architecture was embellished with relief carving and tenoned anthropomorphic heads. The most famous work of architectural relief is the "Gateway of the Sun," a monumental stone gateway that bears reliefs carved on an extended lintel.

Reconstructed Pucará bowl with a protruding feline head.

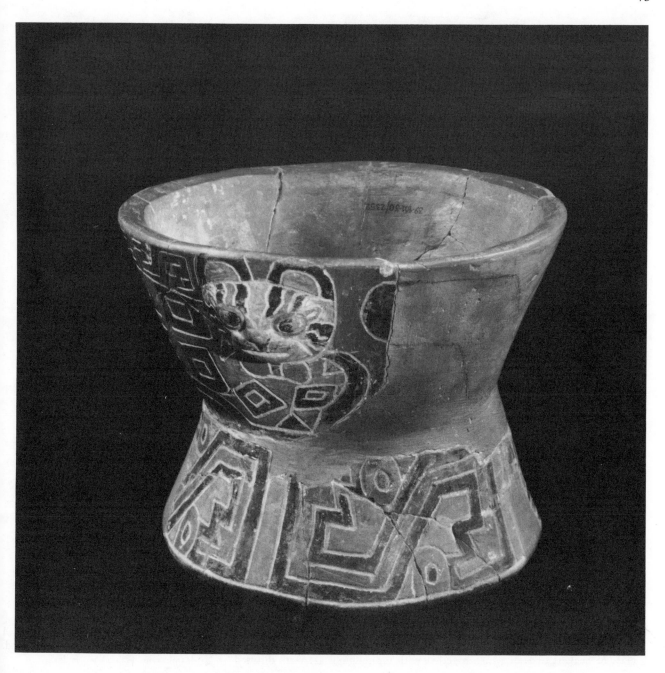

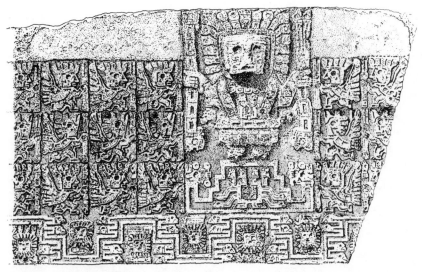

Central relief panel from the Gateway of the Sun, Tiahuanaco, with the Gateway God and flanking birdlike attendants.

The central figure in this frieze is an anthropomorphic deity depicted in a frontal plane with extended arms each grasping a staff, one of which terminates in eaglelike serpent heads. The figure wears an elaborate costume with a row of trophy heads dangling from his belt and a headdress surrounded by rays, some of which end in serpent heads. The head is rectangular in shape, more deeply modeled than the rest of the body, has linear markings diverging downward from the eyes, and possesses a feline mouth. The deity, usually known as the "Gateway God," is flanked by rows of smaller, running figures holding staffs and portrayed in profile; they possess birdlike heads, which probably represent falcons or eagles. The general similarity of this composition to the Staff God of Chavín de Huantar and his avian attendants is obvious, and it may well be that he represents a continuation of the religious pattern first consolidated at Chavín, now manifested in a refurbished southern Peruvian mode and given renewed significance at this important settlement.

The ceramic style of Tiahuanaco, like that of Pucará, utilizes a large-scale polychrome decorative scheme in which felines, birds, serpents, and humans are commonly portrayed. Significantly, the Gateway God also appears in ceramic art as do his avian attendants and distinctive modeled heads that, like the tenoned sculptural examples at Tiahuanaco, project dramatically from a flat background. These heads, sometimes anthropomorphized, may also represent the supreme deity of Tiahuanaco. The most characteristic vessel form of the Tiahuanaco style is a class of beakers or *keros* which together with the religious art were diffused

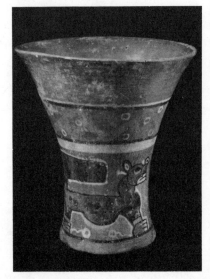

Ceramic *kero*. Tiahuanaco style.

throughout the southern Andes during the period between A.D. 500 and 800.

The Tiahuanaco style had a long developmental history in the Titicaca Basin prior to the middle of the first millennium A.D. However, at this juncture, during what has been termed its "Classic" phase, Tiahuanacoid religious and stylistic motifs rapidly spread throughout the south-central and southern highlands and shortly thereafter to the adjacent coastal valleys, grafting a Tiahuanaco-derived religious element onto the local styles. More specifically, it appears that this Tiahuanacoid religious art was variously interpreted at key religious centers such as Conchopata in the south-central highlands and Pachacamac on the central coast, resulting in a variety of closely linked Tiahuanacoid styles. Such a pattern may well reflect a repetition of the process already seen in the earlier Chavinoid styles. A focal religion, in this case that of Tiahuanaco, with its persisting Chavinoid features, achieved paramount status and was rapidly diffused across southern Peru, being adapted to the specific regional cultures as it spread. The stylistic variation evident within the area of Tiahuanacoid expansion indicates the pacific nature of this diffusion, there being an absence of the forced regularity of architectural and artistic material culture usually associated with intensive imperial conquest. We shall now examine various of the styles which were affected by the Tiahuanacoid expansion.

Styles of the Tiahuanacoid Expansion

Tiahuanacoid ideological impact is evident in the art styles of the entire southern portion of Peru and of the central coast and highlands. Indeed, evidence of minor stylistic influence appears intermittently in the north, demonstrating the profound nature of this vital religious movement. The pattern exhibited by these Tiahuanacoid styles suggests the form of religious diffusion after A.D. 600. There were at least three major centers of stylistic diffusion, each with its own area of influence within the framework of Tiahuanacoid art. These centers were Tiahuanaco in the extreme south, Conchopata in the south-central highlands, and Pachacamac on the central coast. There was possibly another center in one of the south coastal valleys, most probably Ica. It is significant that at least the first three of these diffusional loci appear to have been sites of major religious importance, possibly pilgrimage centers for their respective regions. Indeed, Pachacamac remained an important pilgrimage site throughout pre-Columbian history.

It is probable, then, that the primary mechanism for the diffusion of Tiahuanacoid ideology was one in which traditionally important south Peruvian religious sites embraced the vitalistic religion in all its essentials, but maintained their local importance as centers of the new cult, and in so doing stamped it with their own personalities. The Tiahuanaco, Conchopata, Pachacamac, and Atarco (south coast) regional styles thus maintained their local identity within the broader Tiahuanacoid religious context.

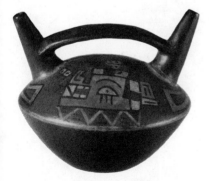

South coast double-spout and bridge polychrome vessel. Atarco style.

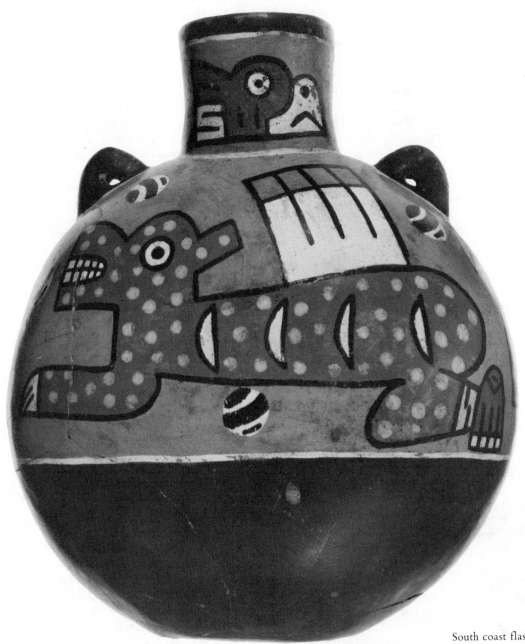

South coast flask. Tiahuanaco style.

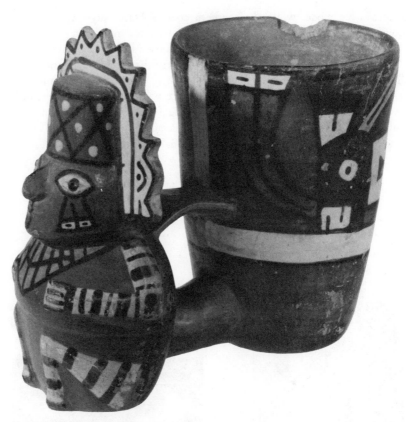

Central coast Pachacamac style vessel with the characteristic Pachacamac "griffin" on the *kero* body.

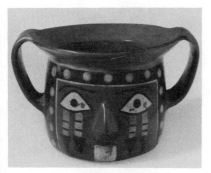

South coast Tiahuanaco style vessel portraying the Gateway God face with characteristic "weeping" eyes.

The regional Tiahuanacoid styles and their descendants all clearly reveal their debt to the parent style. Each replicates the polychrome color scheme and bold design format that typifies the art of Tiahuanaco. Similarly, motifs are generally of large scale and depict a narrow range of religious beings. This pattern is true both for ceramic and textile arts and indicates an effort to communicate well-defined and understood ideological meaning to the viewer. The various styles are distinguished by minor stylistic differences and aspects of iconographic content. Although the supreme deity of Tiahuanaco, the Gateway God, and his winged attendants appear in all of the styles, there is otherwise variation. The Pachacamac style of the central coast emphasizes a falcon with feline body, called the Pachacamac griffin. The Conchopata style of the highlands and its related expressions continue to stress the principal Tiahuanaco religious themes but in a

local decorative mode, while the southern coastal Atarco style retains local religious elements as well as an intrusive Tiahuanacoid component.

Following the decline of the primary Tiahuanacoid styles and their immediate descendants by A.D. 800, Tiahuanacoid-derived expressions continued to recall their artistic and religious themes, though in a much less accomplished manner. The implications of this artistic decline are as yet only poorly understood. However, the decline may denote a period of gradual dissolution of the ideological and cultural unity underlying the period of Tiahuanacoid stylistic expansion prior to subsequent emergence of more distinct regional cultures.

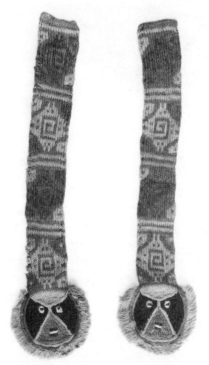

Embroidered tabs. Terminal Tiahuanaco period, Huaura Valley, central coast.

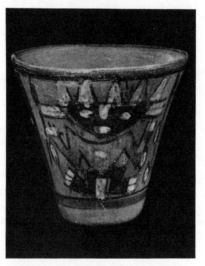

Late Tiahuanaco style *kero* from the central coast, probably portraying the Gateway God.

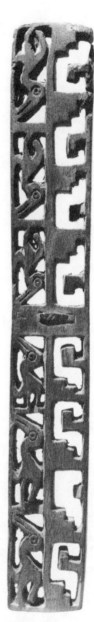

Wooden balance beam with an openwork carving of birds, central coast.

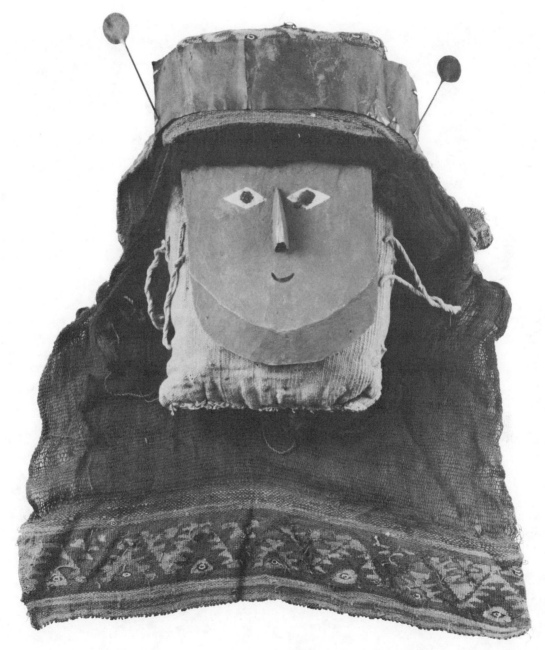

Mummy mask. Silver, wood, and cloth. Terminal Tiahuanaco period, Huaura Valley, central coast.

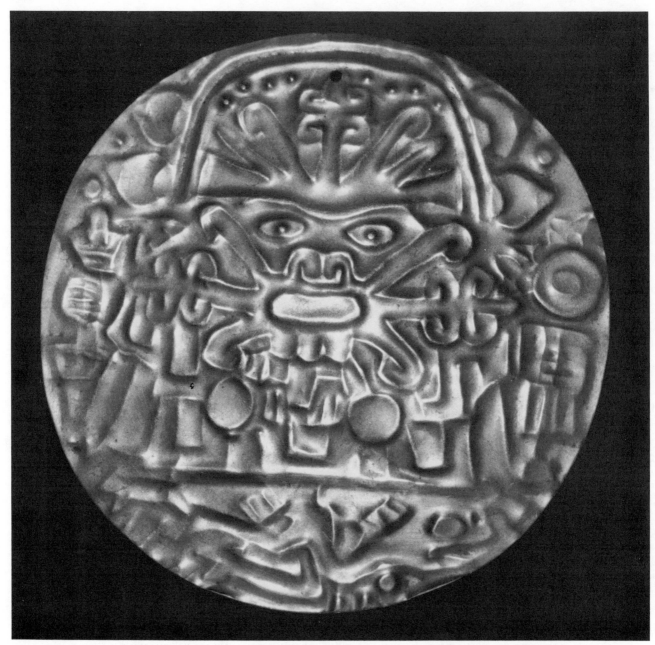

Nazca gold disk with a supernatural being wearing a mouth mask of the same form as that depicted on page 88.

The South Coast Styles

The south coast styles possess an evolutionary course that had its roots in the Chavinoid religious diffusion and its termination in the Inca imperial expansion. The styles displayed in the exhibit — Topara, Nazca, coastal Tiahuanacoid, and Ica — represent the stylistic continuum that developed in the Chincha, Pisco, Ica, Nazca, and Acarí valleys. These styles are the artistic expressions of a sequence whose component cultures were in continuous and close contact with the highlands, a relationship that at times resulted in major impact to the coastal cultures. Such impact resulted from the formative Chavinoid expansion, which furnished much of the general character of all the southern styles, the Inca conquest, which finally unified coast and highland into a wider political entity, and the important period of Tiahuanacoid diffusion, which was discussed in the preceding section.

The cultural context within which the south coast styles developed was probably quite similar to that of the north coast. During the period marked by the Topara and early Nazca styles (ca. 300 B.C.–A.D. 100), the valley irrigation systems were consolidated, and settlement was essentially rural in nature with ceremonial centers providing the administrative focus for single valley polities. Shortly afterward, however, larger settlements emerged containing major corporate structures surrounded by extensive residential areas — in effect, incipient cities. It is at this time that the earliest multivalley political unit was formed, probably with the site of Cahuachi in the Nazca Valley as its capital. This embryonic state was short-lived. In fact, there is at present no strong evidence for another such indigenous state until the time of the Ica style after A.D. 1000, when a multivalley political unit may have flourished, its center in the Chincha Valley, until conquered by the Inca.

As we have previously stressed, the geography and hydraulic capacity of the south coast hindered the development of strong centralized states able to resist highland intrusion. Thus, much of the Nazca and succeeding south coast Tiahuanacoid styles evolved within the context of small political units often closely associated with the highlands but never approaching the size or longevity of the contemporary Moche state of the north coast. Although archaeological evidence from the south coast is presently inadequate for tracing administrative patterns, the related art styles possess a distinctly religious focus throughout their Nazca and Tiahuanacoid expressions. It follows that during this period there was a strong religious aspect to social organization and government. The later Ica style presents a much less obvious religious character, possibly reflecting an increase in secular state functions after A.D. 1000 similar to the trend documented for the north coast.

Topara

The Topara or Paracas Necropolis ceramic style dates from about 300 B.C. to A.D. 100 and was first discovered by the great Peruvian archaeologist Julio Tello

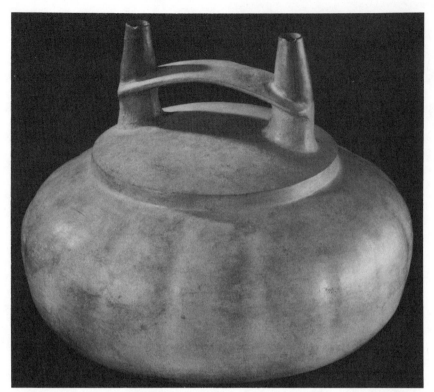

Topara double-spout and bridge vessel.

at a site near the Bay of Pisco. Topara ceramics occur at very extensive cemeteries that also contain large quantities of rich funerary offerings including many fine textiles. Topara pottery is closely related to the earlier Chavinoid Paracas style in form but differs in that it is usually decorated in high gloss cream-white or orange monochrome paint. The most common form is a large, squat jar with double spouts connected by a handle. It is quite possible that this ceramic style is a local variant of the wider Paracas stylistic development, which evolved smoothly in the southern valleys from its Chavinoid origins into later Nazca art.

The Paracas Necropolis textiles associated with Topara pottery (and well represented in the Museum collections) rank among the finest examples of Andean weaving technology. They were manufactured from llama wool and cotton. Techniques include warp- and weft-stripe, lace, brocade, tapestry, and double cloth. Intricate designs of animals, humans, and supernatural beings are embroidered on dark backgrounds, producing an exquisite jewellike effect. These designs are replicated in the pottery of the closely related Nazca style.

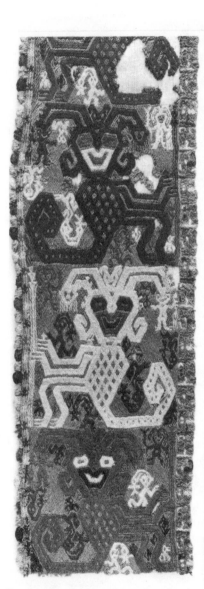

Paracas Necropolis style. Embroidered alpaca and cotton textile.

Nazca

The Nazca style is one of the best known of the ancient Peruvian artistic expressions. The style, which evolved from the earlier Chavinoid Paracas style, dominated southern coastal art from about 300 B.C. to A.D. 700. Like most other southern Peruvian styles, Nazca is characterized by the use of polychrome painting and large-scale design. Although the Nazca potters were fully capable of making naturalistic modeled forms and often did, modeling does not dominate the style to such a degree as it does northern coastal art. Major ideological communication in Nazca art was by means of painted design not sculptural form.

Nazca art is most familiar through its ceramic component; however, it is also known through the medium of weaving. There are two separate thematic ingredients in Nazca art, one stressing representational motifs and the other stressing religious subjects. A wide range of animals, birds, and marine life is depicted in the representational art. Often such subjects are repeated in bands around the bodies of vessels or are woven into textiles. Sometimes single large subjects are portrayed, especially as decoration for the interiors of bowls and plates. The important religious component of Nazca art comprises a group of stylized and anthropomorphic supernatural beings, each with its own well-defined formal features and accoutrements. Feline motifs dominate this iconographic category. Designs, whether abstract or naturalistic, are multicolored and outlined in black on red-brown or cream backgrounds, color contrast being fully exploited to emphasize the decorative content. Common vessel forms are the open bowl, the double-spouted jar, and the vessel with single spout and bridge.

The Nazca style underwent gradual evolution through time. In its earliest phase the style retained many Paracas characteristics, demonstrating its origins in the earlier Chavinoid style. Moreover, early Nazca motifs were rendered in a boldly monumental manner, free of detail and filler decoration. Realistic representation was more important than in later phases. This bold, simple expression subsequently evolved into a much more complicated abstract style in which naturalism was largely abandoned, stylized beings dominated the content, and surfaces were covered with decorative filler motifs. Late in its development Nazca art exhibited progressively closer contact with the highlands, a trend that culminated in a stylistic merger during the period of Tiahuanacoid expansion when the south coast Atarco style in essence constituted a balanced blend of Tiahuanacoid and indigenous Nazca features.

South coastal metallurgy, unlike that of the highlands, was relatively underdeveloped during the Nazca period. However, ornaments and masks of beaten gold, which repeat the motifs seen on textile and pottery, do occur in burial contexts. A final stylistic feature, unique in its areal extent, is the remarkable group of ground markings commonly called the "Nazca lines." These markings on the flat desert plain north of the Nazca Valley were made by removing small

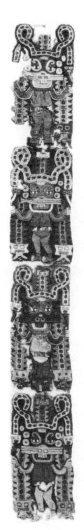

Paracas Necropolis style. Embroidered alpaca and cotton textile.

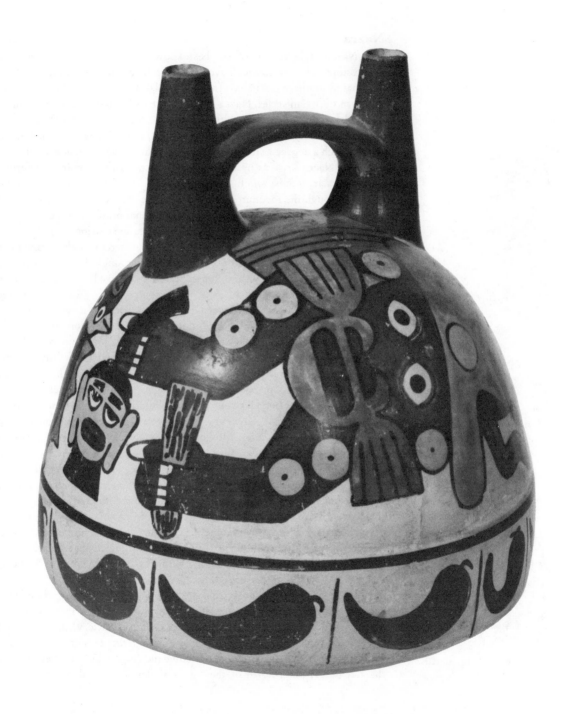

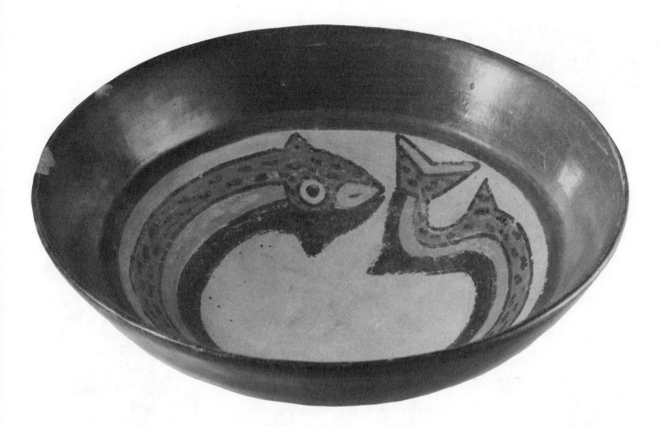

Nazca open bowl with a fish design.

Early Nazca style polychrome vessel with a supernatural being holding a trophy head.

stones from the surface in regular patterns, thus exposing the lighter-colored sand beneath. The resulting designs include straight lines, geometrical motifs, and animal forms. Some of the latter resemble the motifs that appear on Nazca pottery and textiles, indicating their probable chronological identification with this style. Various ideas have been offered to explain these lines, the most feasible suggesting that they replicated astronomical formations or were used to facilitate communication with sky deities. However, such theories must at this juncture be regarded as speculative.

Ica

The Ica style was the principal artistic expression of the northern valleys of the south coast during the period immediately preceding the Inca conquest. The style may be associated with a multivalley state centered in the Chincha Valley; however, the existence and extent of political unification at this time is still

88

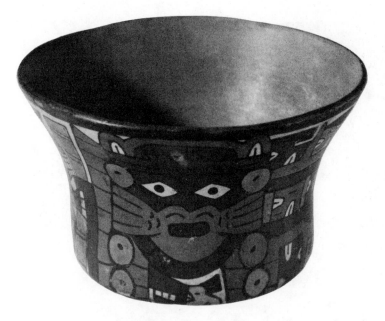

Nazca polychrome bowl with a supernatural being wearing a mouth mask.

uncertain. Large settlements focused around pyramids and plazas certainly indi-cate the presence of complex administrative structures in the southern valleys at this time.

The Ica art style maintains the characteristic southern Peruvian polychrome scheme with red, white, and black as the principal colors. However, both the naturalistic element and religious content of the earlier Nazca and Tiahuanacoid styles are now rejected, decoration being executed in geometric patterns that appear to duplicate those of contemporaneous Ica textiles. Where naturalistic motifs are retained, as in the case of fish and bird designs, they are stylized in the extreme. The Ica style is thus a late development of the long southern coastal artistic tradition in which naturalistic representation was gradually lost in the transition from Nazca to Ica art during the derived Tiahuanacoid styles of about A.D. 800 to 1100. While traditional decorative canons are retained, all religious iconographic content is abandoned. It is tempting, although speculative, to see this change as a reflection of a trend toward the evolution of a secularly oriented society in the region similar to that which emerged on the north coast with the Chimú empire.

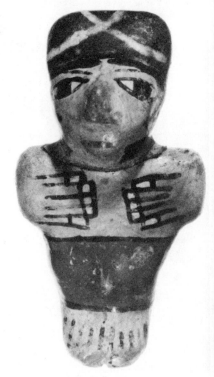

Nazca miniature pottery figurine.

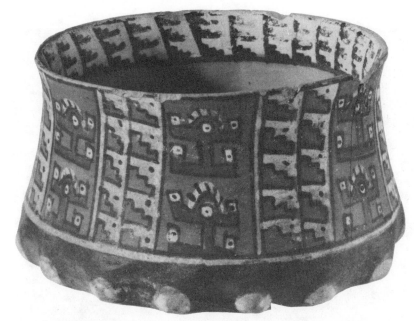

Ica polychrome vessel.

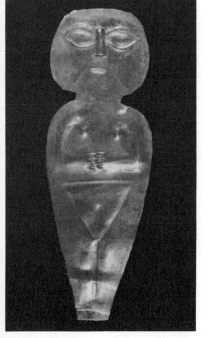

Nazca gold figure.

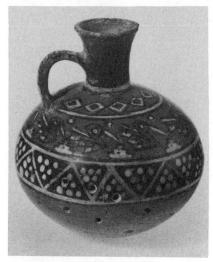

Ica polychrome vessel.

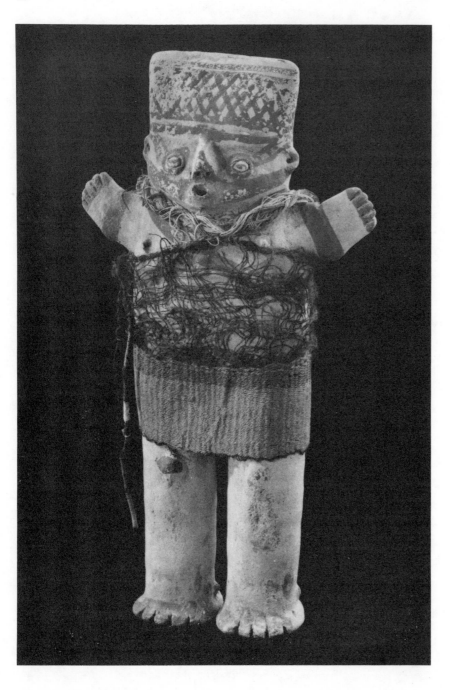

Chancay figurine with a woven garment.

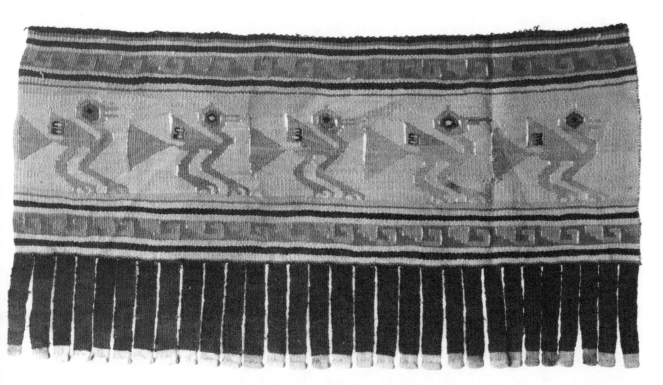

Chancay slit tapestry. Alpaca and cotton.

The Central Coast: Chancay

Of the art styles that emerged on the central coast following the Tiahuanacoid expansion and its derived forms, the Chancay style of about A.D. 1200 is best represented in the Peabody Museum collections. The Chancay style and its immediate predecessors exhibit little affinity with their Tiahuanacoid ancestors, possibly like the Ica style of the south coast, and unlike their immediate predecessors, developing in relative isolation. This scenario implies that direct highland influence on the coast during the period following A.D. 800 was much reduced.

The political structure of the home valleys of the Chancay style — Huaura, Chancay, Ancón, and Chillón — is not certain. However, archaeological evidence indicates the presence of a fairly homogeneous culture, which may also have been politically unified. If this is so, it would explain the strong defensive structures built by the Chimú empire after it expanded into the area in the early fifteenth century as protective devices against a dangerous neighbor or as remedial measures taken to prevent organized resistance by a defeated but powerful enemy. In any case, the Chancay culture achieved a high degree of urban development and

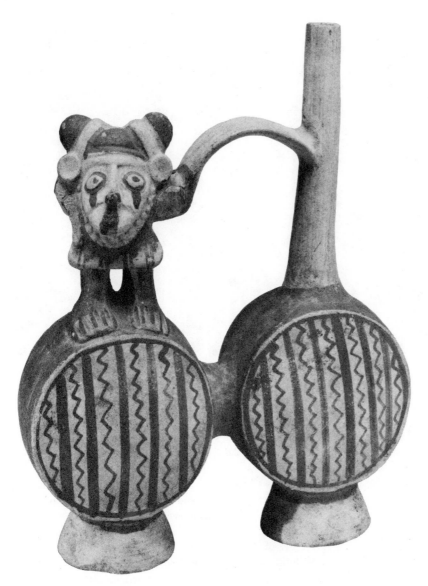

Chancay double-chambered vessel bearing humanlike adorno.

technological prowess, with large ceremonial and residential settlements spread throughout its component valleys among extensive agricultural works in the form of terraces, reservoirs, and canals. This hydraulic technology mirrors that of the

Chancay tapestry. Alpaca and cotton.

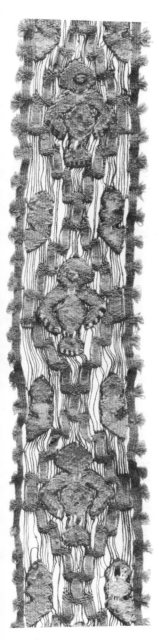

north coast during the period immediately preceding the Inca conquest in marking the culminating achievements of pre-Columbian coastal irrigation engineering. Clearly an ability to organize and manipulate large populations was a necessary concomitant to such projects.

The Chancay style is very distinctive. It is white-slipped with black-line decoration that is generally geometric in form, with parallel lines and checkered areas dominating. Small appliqué figures are also used. A degree of primitiveness unusual in Peruvian art permeates the Chancay style, giving it a highly individual quality. Crudely formed human figurines are common as are tall, collared, double-handled jars and vessels bearing human and animal faces on their necks.

Cloth was also produced in great quantities by the Chancay culture and is of a quality considerably superior to that of the pottery, thus implying its aesthetic priority in Chancay art. Tombs are notable for textiles that display a variety of manufacturing techniques including brocade, gauze, openwork, and painted plain weave. Like all of the late regional cultures, Chancay was incorporated into the Inca Empire in the fifteenth century A.D., after which the art of the central coast again showed dominant influence from the highlands.

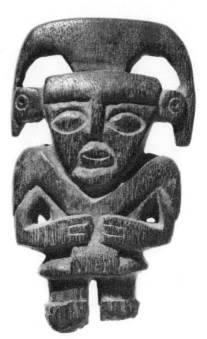

Detail of the Chancay tapestry on preceding page.

Chancay wooden staff head.

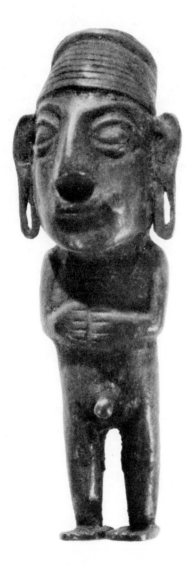

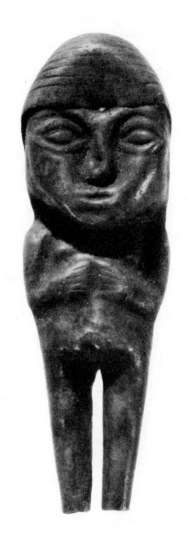

Inca miniature human figurines. Silver.

Pan-Andean Empire: The Inca Styles

We have stressed the point that one of the most consistent themes of pre-Columbian Peruvian history is the tendency of the southern highlanders to intrude into the coastal plain. Such involvement took many forms, at various times manifesting itself through religious, political, and economic expansion with intervening periods of local hegemony, and even minor episodes of coastal influence in the highlands. This trend culminated in the mid-fifteenth century when a previously minor highland tribe, the Inca, initiated a swift process of military expansion from their power base in the Cuzco Basin. Under three energetic rulers, Pachakuti, Topa Inca, and Huayna Capac, the Inca state rapidly expanded to include by A.D. 1500 the whole of present-day Andean Peru, Ecuador, and Bolivia, and large portions of Argentina and Chile, thus constituting one of the largest empires ever created.

The Inca evolved an extremely efficient administrative system to control their vast domains. Dual capitals at Cuzco and Quito were the centers of a complex network of paved roads that traversed the empire. Local administration was conducted from smaller centers by Inca governors supported by bureaucrats and soldiers. Little large-scale colonial settlement was undertaken by the Inca themselves; they remained an alien ruling elite in their subjugated provinces. This administrative pattern is clearly reflected in material culture of the imperial period where intensive Inca forms constitute the highest status expressions of art and architecture. Imitations and blendings show the efforts of local elites to attain the trappings of power, with traditional local styles persisting as the appurtenances of the lower classes, who generally were least affected by the conquest. These various levels of material influence and hybridism were far from complete when, a bare half century after its consolidation, the empire collapsed in the face of internal disorder and foreign invasion, the Spaniards becoming the inheritors of the Inca territories.

Inca Style

Inca ceramic art of the imperial period displays its southern Peruvian origins in the use of brightly painted polychrome motifs but only secondary use of modeling. Black, white, and red designs are usually geometric, with favorite schemes being composed of rows of diamonds, checks, serrations, and cross-hatching. Where naturalistic forms such as birds and animals are used, they are greatly stylized and generally conform to an abstract and geometric design pattern. Typical vessels are beakers — traditional southern highland forms — and pointed-based aryballoid jars with two handles and long necks. These vessel forms are found throughout the Inca imperium. Their direct relationship outside of the southern highlands with intrusive Inca administrative centers indicates that they were chiefly used by the

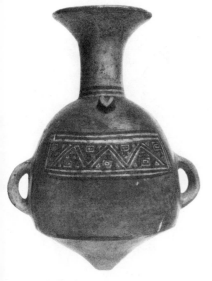

Inca aryballoid vessel.

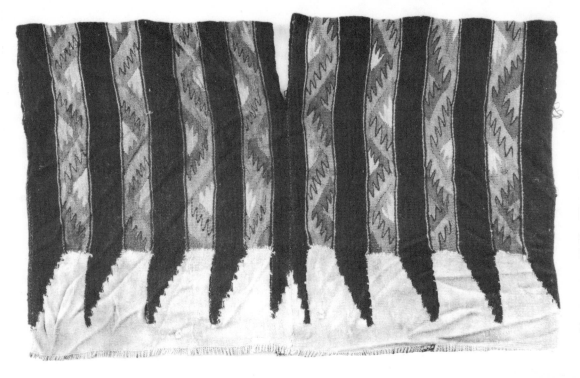

Alpaca tunic. Inca period.

governing elite and represent imported status items.

Inca art is also expressed through other media. Metallurgy was highly refined, and a wide range of bronze, copper, and precious metal ornaments, tools, and weapons were manufactured. Wood carving was widely practiced under the Inca, one of its most characteristic products being the wooden goblet or *kero*. This wooden form has a long developmental tradition in the southern highlands, although earlier vessels such as the well-known Tiahuanacoid *keros* were made chiefly of pottery. *Keros* bore carved decoration during the imperial Inca period and continued to be made after the Spanish conquest, when they were decorated with lacquered designs. Finally, Inca textiles constituted an important vehicle for artistic expression. Textiles carried important economic and social status, and the finest examples were manufactured by upper-class women under state supervision. This procedure contributed to their fine quality. Primary decorative modes follow those of ceramic art in utilizing bold geometric banded motifs with striking color contrast.

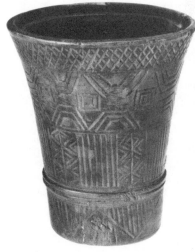

Wooden *kero*. Inca period.

Bronze llama. Inca period.

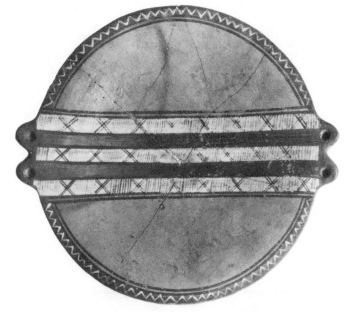

Inca plate.

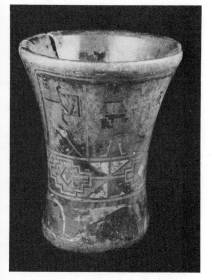

Inca wooden *kero* of early Spanish Colonial date. The vessel is lacquered in the Spanish style and depicts Inca subjects.

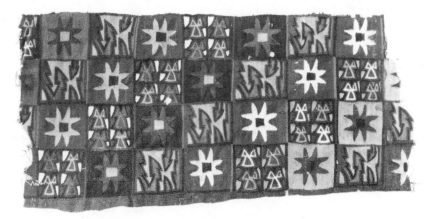

Alpaca tunic. Inca period.

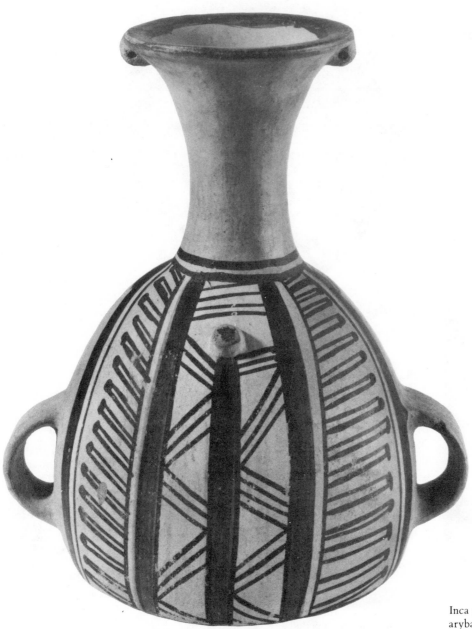

Inca provincial style
aryballoid vessel, Chancay Valley.

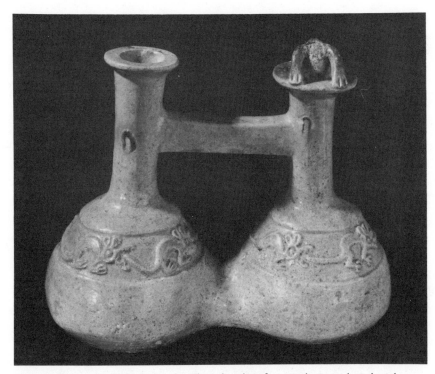

Chimú-Inca provincial style vessel with a glazed surface. Early Spanish Colonial period.

Inca-influenced Styles

Although the expanding Inca Empire incorporated states and cultures possessing strong artistic traditions, there appears to have occurred almost universally a partial blending of local styles with the imperial style. This tendency reflects the adoption by local elites of Inca influences, the imperial material trappings representing symbols of high status. Thus in art, the foreign highland traits were blended with resident traditions to form hybrid styles that exhibited affinities to each ancestral strain.

Well-defined examples of cultural fusion expressed through art are the Inca-dominated Chimú art of the north coast, Chancay art of the central coast, and Ica art of the south coast. In each case strong indigenous features are overlain by or blended with typical Inca stylistic traits. Such blending takes various forms. Sometimes a typical Inca vessel is painted in local fashion; often hybrid vessel shapes were produced; and occasionally local vessels were embellished with Inca decoration. Whatever the direction taken, this Inca-colonial trend toward amal-

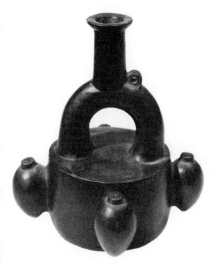

Chimú-Inca provincial style vessel, Moche Valley.

gamation was only partially fulfilled by the time of the Spanish conquest. From this time, indigenous stylistic expressions were influenced by European modes, and Inca art together with that of its regional colonial manifestations were immersed in a Spanish provincial artistic milieu.

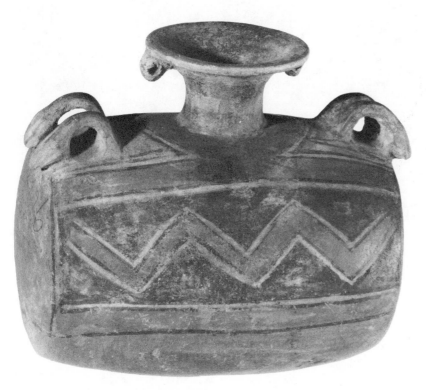

Ica-Inca provincial style vessel, Ica Valley.

Epilogue

The Spanish conquest put an end to the independent history of Peruvian civilization, but not to that civilization itself or to its peoples. Today, some thirteen million Indians live within the former borders of Tawantinsuyu. Though their lives have been changed by Western influences, many elements of native culture have survived. Nearly eighty percent of Andean Indians speak Quechua. In remote villages the inhabitants still see their world as divided into quarters, and herdsmen count their flocks with quipus. In conjunction with Christian beliefs, the worship of the ancestors persists, and people in trouble seek the help of shamans. The list could go on and on.

In the same way, the Peruvian artistic tradition has managed to accommodate Spanish influences while maintaining its own unique character. Native weavers and potters continue to produce objects that are both beautiful and full of meaning. There are numerous distinctive local and regional styles, especially in the southern highlands, where the tradition is most vigorous. The differences between ponchos from Cuzco and Puno or ceramics from Ayacucho and Pucará are easily recognizable.

Much Peruvian folk art is still imbued with religious symbolism, either native (the sun and solar motifs) or Christian (the pottery church models and retablo icons of Ayacucho, etc.). Furthermore, Peruvian artists of mixed European and Indian descent are finding prehistoric iconographies a rich source of inspiration for their own work. Four hundred and fifty years after Atauhualpa's death, the heritage of Peru's ancient cultures is still strong.

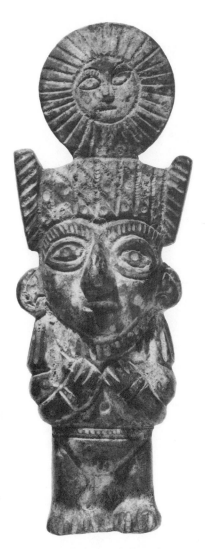

Inca bronze figurine of the early Colonial period demonstrating the persisting importance of the sun in Inca religion.

General Bibliography

General Archaeology of Peru

Kosok, Paul
 1965 *Life, Land, and Water in Ancient Peru.* Long Island University Press. New York.

Lumbreras, Luis G.
 1974 *The Peoples and Cultures of Ancient Peru.* Smithsonian Institution Press. Washington, D.C.

Moseley, Michael E.
 1978 "The Evolution of Andean Civilization," in *Ancient Native Americans,* edited by Jesse D. Jennings, pp. 491–543. W.H. Freeman and Company. San Francisco.

Willey, Gordon R.
 1971 *An Introduction to American Archaeology: Volume 2: South America,* pp. 76–194. Prentice-Hall, Inc. Englewood Cliffs, New Jersey.

Inca

Brundage, Burr C.
 1967 *Lords of Cuzco.* University of Oklahoma Press. Norman.

Cieza de León, Pedro de
 1976 (1553) *The Incas.* Edited by Victor Wolfgang von Hagen. Translated by Harriet de Onis. University of Oklahoma Press. Norman.

Demarest, Arthur A.
 1981 *Viracocha: The Nature and Antiquity of the Andean High God.* Monographs of the Peabody Museum of Archaeology and Ethnology, vol. 6. Cambridge, Massachusetts.

Gasparini, Graziano, and Luise Margolies
 1980 *Inca Architecture.* Translated by Patricia J. Lyon. Indiana University Press. Bloomington.

Rowe, John H.
 1967 "What Kind of Settlement Was Inca Cuzco?" *Nawpa Pacha,* vol. 5, pp. 59–77.

Central and North Coasts

Donnan, Christopher B.
 1978 *Moche Art of Peru.* Museum of Cultural History, University of California. Los Angeles.

Feldman, Robert A.
　　1977　"Life in Ancient Peru," *Field Museum of Natural History Bulletin,* vol. 48, no. 6, pp. 12–18. Chicago.

Kroeber, Alfred L.
　　1926　"The Uhle Pottery Collections from Chancay," *University of California Publications in American Archaeology and Ethnology,* vol. 21, no. 7, pp. 265–292. Berkeley.

Menzel, Dorothy
　　1977　*The Archaeology of Ancient Peru and the Work of Max Uhle.* R.H. Lowie Museum of Anthropology, University of California. Berkeley.

Moseley, Michael E.
　　1975　*The Maritime Foundations of Andean Civilization.* Cummings. Menlo Park.
　　1975　"Prehistoric Principles of Labor Organization in the Moche Valley, Peru," *American Antiquity,* vol. 40, pp. 191–196.

Moseley, Michael E., and Kent C. Day, editors
　　1982　*Chan Chan: Andean Desert City.* University of New Mexico Press. Albuquerque.

Rowe, John H.
　　1948　"The Kingdom of Chimor," *Acta Americana,* vol. 6.

Shimada, Izumi
　　1981　"Temples of Time: The Ancient Burial and Religious Center of Batan Grande, Peru. *Archaeology,* vol. 34, no. 5, pp. 37–46.

South Coast

Gayton, Anna H., and Alfred L. Kroeber
　　1927　"The Uhle Pottery Collections from Nazca," *University of California Publications in American Archaeology and Ethnology,* vol. 24, no. 1, pp. 1–46. Berkeley.

Menzel, Dorothy
　　1977　*The Archaeology of Ancient Peru and the Work of Max Uhle.* R.H. Lowie Museum of Anthropology, University of California. Berkeley.

Menzel, Dorothy, J.H. Rowe, and L.E. Dawson
　　1964　*The Paracas Pottery of Ica: A Study in Style and Time. University of California Publications in American Archaeology and Ethnology,* vol. 50. Berkeley.

Reiche, Maria, and Hermann Kern
　　1974　*Peruvian Ground Drawings.* Kunstraum Munchen e. V. Munchen.

104

Roark, Richard Paul
1965 "From Monumental to Proliferous in Nazca Pottery," *Nawpa Pacha,* vol. 3, pp. 1–92.

Southern Highlands

Bennett, Wendell C.
1934 "Excavations at Tiahuanaco," *American Museum of Natural History Anthropological Papers,* vol. 34, no. 3, pp. 359–494. New York.
Isbell, William H., and Katharina J. Schreiber
1978 "Was Huari a State?" *American Antiquity,* vol. 43, no. 3, pp. 372–390.
Kidder II, Alfred
1943 *Some Early Sites in the Northern Lake Titicaca Basin.* Papers of the Peabody Museum of Archaeology and Ethnology, vol. 27, no. 1. Cambridge, Massachusetts.
MacNeish, Richard S., Angel Garcia Cook, Luis G. Lumbreras, Robert K. Vierra, and Antoinette Nelken-Terner
1981 *Prehistory of the Ayacucho Basin, Peru: Volume II.* University of Michigan Press. Ann Arbor.
Menzel, Dorothy
1964 "Style and Time in the Middle Horizon," *Nawpa Pacha,* vol. 2, pp. 1–105.

Central and Northern Highlands

Burger, Richard L., and Lucy Salazar Burger
1980 "Ritual and Religion at Huaricoto," *Archaeology,* vol. 33, no. 6, pp. 26–32.
Grieder, Terence
1978 *The Art and Archaeology of Pashash.* University of Texas Press. Austin.
Lumbreras, Luis G.
1971 "Towards a Re-evaluation of Chavín," in *Dumbarton Oaks Conference on Chavín,* edited by E.P. Benson, pp. 1–28. Washington, D.C.
Rowe, John H.
1962 *Chavín Art: An Inquiry into Its Form and Meaning.* Museum of Primitive Art. New York.
Tello, Julio
1960 *Chavín. Cultura matriz de la civilización Andina.* Lima.

Illustration Credits

Courtesy of R. A. Feldman, Field Museum of Natural History: vi, 24

Courtesy of the American Museum of Natural History: 8, 29

Drawn by L. E. Demarest: 76 (top left)

Courtesy of Prentice-Hall, Inc., Englewood Cliffs, N.J.: 25, 26, 27, 47, 49

Courtesy of Chan Chan-Moche Valley Project, Harvard University: 10, 33, 34, 35 (top right), 66

Drawn by Whitney Powell: 6 (after a drawing by H. Lechtman), 11, 14, 20, 32, 35 (bottom left), 46

Photographs by Garth Bawden: 12, 13, 15, 38, 39

Redrawn by Garth Bawden: 36 (top), 60 (top)

Photographs by Hillel Burger: cover, 40, 50, 52, 53, 54, 57 (top), 57 (bottom), 58, 59, 60 (bottom), 61, 62, 63 (left), 63 (center), 63 (right), 64 (top), 64 (bottom), 65, 67 (left), 67 (right), 68, 70, 72, 75, 76 (bottom right), 77, 78, 79 (top right), 79 (bottom left), 80 (left), 80 (center), 80 (right), 81, 82, 84 (left), 84 (right), 85, 86, 87, 88 (left), 88 (right), 89 (top right), 89 (bottom left), 89 (bottom right), 90, 91, 92 (left), 92 (right), 93 (left), 93 (right), 94, 95, 96 (top), 96 (bottom), 97 (top left), 97 (top right), 97 (bottom left), 97 (bottom right), 98, 99 (top right), 99 (bottom left), 100, 101

Peabody Museum Catalogue Numbers for Illustrated Objects

Page:

40	46–77–30/4902	80 right	46–77–30/6080
50	58–51–30/8164	81	42–12–30/3541
52	968–14–30/8614	82	15–41–30/86928
53	58–51–30/8170	84 left	46–77–30/5304
54 (left pair)	42–12–30/3177, 3178	84 right	32–30–30/50
(right pair)	46–77–30/6118	85	32–75–30/F857
57 top	46–77–30/4912	86	16–41–30/A2670
57 bottom	47–63–30/5680	87	968–14–30/8500
58	46–77–30/4913	88 left	32–30–30/72
59	46–77–30/5050	88 right	46–77–30/5346
60 bottom	46–77–30/4980	89 top	15–14–30/86876
61	16–62–30/F728	89 bottom left	73–6–30/7292
62	16–62–30/F725	89 bottom right	46–77–30/5292
63 left	12–63–30/87724	90	41–52–30/2951
63 center	46–77–30/6276	91	63–12–30/8449
63 right	46–77–30/5853	92 left	46–77–30/6690
64 top	86–28–30/39789	92 right	46–77–30/9095
64 bottom	968–14–30/8540	93 right	46–77–30/6140
65	09–3–30/75598	94 (left)	09–3–30/75515
67 left	12–63–30/87859	(right)	09–3–30/75514
67 right	46–77–30/6158	95	12–63–30/87898
68	09–3–30/75523	96 top	42–12–30/3548
70	09–3–30/75594	96 bottom	42–12–30/3414
72	32–30–30/84	97 top left	67–9–30/2522
75	39–101–30/2352	97 top right	10–47–30/76806
76 bottom	46–81–30/5485	97 bottom left	46–77–30/6935
77	42–28–30/4494	97 bottom right	32–75–30/F856
78	46–77–30/5405	98	968–14–30/8501
79 top	46–77–30/5170	99 top	12–63–30/87913
79 bottom	32–30–30/69	99 bottom	42–28–30/4380
80 left (left)	46–77–30/9662	100	08–33–30/73868
(right)	46–77–30/9663	101	87–61–30/54436
80 center	968–4–30/8586		